THE JOHN F. KENNEDYS

A FAMILY ALBUM

THE JOHN F.

INTRODUCTION BY

RIZZOLI

BY MARK SHAW

KENNEDYS

RICHARD REEVES

NEW YORK

First published in the United States of America in 2000 by

RIZZOLI INTERNATIONAL PUBLICATIONS, INC.

300 Park Avenue South

New York, New York 10010

Copyright © 2000 The Mark Shaw Photographic Archive

Images © 2000 The Mark Shaw Photographic Archive

Introduction © 2000 by Richard Reeves

ISBN 0-8478-2273-7 (HC)

ISBN 0-8478-2353-9 (PB)

LC 99-75924

Design by Louise Fili and Mary Jane Callister, Louise Fili Ltd

Printed in Canada

Reprinted in 2000

This revised edition is dedicated to JOHN F. KENNEDY JR.

and to all young men who because of death, duty, or circumstance must courageously

find their own path alone, without the wisdom, support, and love of their fathers.

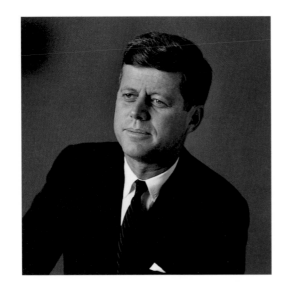
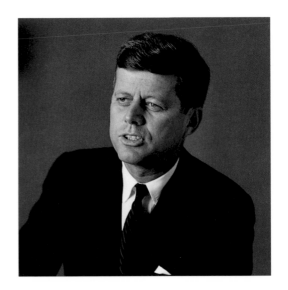
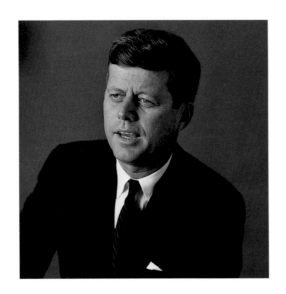
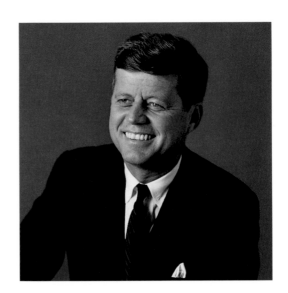

Introduction BY RICHARD REEVES

John F. Kennedy was the most impatient of men. He lived life as a race against boredom,
using everything and everyone he could, including his own family, for amusement, for
education, for promotion. The oldest and most experienced of the men who served him
in the White House, Averill Harriman, put a time to J.F.K.'s attention span—seven sec-
onds. The old man, whose service went back to early in Franklin D. Roosevelt's time,
told younger men that the only way to reach President Kennedy was to hang around
the halls of the White House and bump into him with a prepared message, rehearsed
and timed to six seconds. No more—"You'll lose him."

But there was one thing President Kennedy always had time for: he would spend
hours looking at photographs of himself and his family. That was neither narcissism
nor pride to Jack Kennedy, but recognition of politics as a show of fleeting images. In
the mostly black-and-white world of the early 1960s, the right picture in the right place
duplicating itself forever was worth a great deal more than any thousand words. One
enduring image, say a photograph of the young senator walking away from the camera
through Hyannis Port dunes to the sea, might have the political impact of a small war.
Selecting the right image at the right time was at the heart of winning the elusive twin
goddesses the man pursued, power and history.

That photograph in the dunes, Kennedy's favorite picture of himself, was taken in
early 1960 by Mark Shaw, a 37-year-old New Yorker who had made his name as a bril-
liant and creative fashion photographer. That year Shaw met Kennedy in an ordinary
way, on assignment for *Life* magazine. He was a little younger than Kennedy was, but

both were veterans of the war that defined their American generation and both were men of surpassing charm. No small thing. People were attracted to both of them. It was impossible, really, not to be attracted to the image in the dunes—that was important and Kennedy knew it.

The man who would be president also understood the opposite impact of the wrong image. That same year, *Life*'s sister magazine, *Time*, assigned one of its most talented young writers, Hugh Sidey, to write about Kennedy, to get to know him. On second meeting, Sidey and Kennedy were walking near the short subway that connects the U.S. Capitol with the Senate Office Building. They bumped, almost literally, into Kennedy's buddy Senator George Smathers of Florida, who was posing for a Senate photographer with a small claque of pretty young women from his state. All laughing, they pulled the handsome young senator from Massachusetts into the group and he smiled for the birdie.

Waving goodbye to the gigglers, Kennedy said to Sidey, "Get hold of that photographer and destroy the negative."

Sidey did it.

President Kennedy had learned the power of the image, of the visual, from his father, who was for a time a power in the movie business. Joseph P. Kennedy was the first, or among the first, to merge the creation and marketing of the celebrity trade, the tricks of public relations, to the business of politics and governing. With politics aforethought, the founding father had created an archive—still and moving pictures of his children—ready to be used to entice a nation into a cause in the same way they were pulled into movie theaters.

Because of their wealth and Dad's business, the Kennedys were making high-quality color home movies when most Americans were using Brownies—or still posing in front of seaside scenes at arcades. The Kennedy saga continues and endures, in large

part, because it is picture-driven. There is just so much dazzling footage and so many evocative photos indexed in our shared experience. The images are imbedded deeper and deeper in the American psyche with each election, each adventure, each wedding, each funeral. Visually, the Kennedys are supply-side history.

So John F. Kennedy was his own photo editor as politician and, especially, as President. He knew the power of the body on film. Like Franklin D. Roosevelt before him, he was almost never photographed on the crutches he often needed because of his horrible back troubles. Suffering was not to be mixed with images of youth, vigor, children, laughter, and the sea. Engaged in struggle to provide health care for the poor, he refused to be photographed with his principal adversary, the president of the American Medical Association. Such a picture could undermine, could be used to intimate compromise was at hand. He also refused to meet Martin Luther King Jr. within camera range until after the black leader's triumphant "I have a dream" speech at the Lincoln Memorial in the summer of 1963.

And the young President was perfectly willing to exploit his children as his father had promoted the family. In Jack Kennedy's case, he often had to do it over the objections or behind the back of his wife. There was a pattern to the photo stories on the President's children. Most were staged when Jacqueline Bouvier Kennedy was away from the White House. When she left for a Mediterranean holiday with her sister, Lee Radziwell, in 1963, the President immediately called an editor at *Look* magazine, Laura Bergquist, who had proposed a picture story to be titled "The President and His Son" and shot by a staff photographer named Stanley Tretick.

"This is it," said the father to the editor. "We'd better get this over with quick because when Mrs. Kennedy is around things get pretty sticky."

Indeed they did. Mrs. Kennedy was determined to protect her children from the image-greed of cameras. She also had a feel for the appropriate, quite different from

her husband's ironic view of life and politics. There is a wonderful memo from Mrs. to Mr. Kennedy that reads: "I was passing by Mrs. Lincoln's office today and I saw a man [Congressman Aspinall] being photographed in the Rose Garden with an enormous bunch of celery. I think it is most undignified for any picture of this nature to be taken on the steps leading up to the President's office or on the South grounds. If they want their pictures taken they can pose by the West Lobby. This also includes pictures of bathing beauties, etc."

Mark Shaw did not do celery or ordinary members of Congress. He was the chosen photographer of an international set of the gifted and the beautiful—Picasso, Chagall, Saint Laurent, Chanel, and Audrey Hepburn, Grace Kelly, Cary Grant.

It was not that his eye made any of them more beautiful; he made them more human. Mark Shaw was so good that he could get away with calling his work "snapshots"—as if anyone could do it. His pictures looked different, impressionistic. He shot in 35mm at a time when most published photographs were still being produced from sharper-focused and larger negatives made with the 2.25 x 3.25–inch to 4 x 5–inch Graflex cameras beloved of newspaper photographers. Most of his Kennedy photographs were indeed snapshots—the couple did not sit for him, they lived for him—and were done with wide-angle lenses giving those beautiful people both softness and context. Shaw was a master of technique that looked casual and artistic at the same time. The 35mm images were grainier, but the wide lens separated subject and background in a manner that spoke of art in a photo world of flatter mechanical images.

Which, of course, was why Jacqueline Kennedy loved his work. In an irony, Jack Kennedy, artistically a man of the people, knew what he liked and what worked for him in painting and photography, but his favorite art was the popular, particularly musical comedy, the craft of Shaw's wife, Pat Suzuki, a Broadway star of the day. So it was not surprising that on the famous night that Mrs. Kennedy brought high culture into the

White House, in the person of the great cellist Pablo Casals, only one photographer was allowed in the East Room. Mark Shaw.

Nor was it surprising that the President's wife became the artist's patron. Only two weeks before Kennedy was assassinated, Mrs. Kennedy wrote a note to Shaw, one of many, thanking him for color photographs of her with her three-year-old, John F. Kennedy Jr.:

> They really should be in the National Gallery! I have them propped up in our Sitting Room now, and everyone who comes in says the one of me and John looks like a Caravaggio—and the one of John, reflected in the table, like some wonderful, strange, poetic Matisse. And, when I think of how you just clicked your camera on an ordinary day in that dreary, green Living Room.
>
> I just can't thank you enough, they will always be my greatest treasures. Anyone who puts a finger-print on them will have his hand chopped off.

There was, however, the usual tension between friends whose work or purposes were different. "Jackie," as she signed personal letters, wrote six longhand pages to "Dear Mark" about his use (or sale) of family photographs, saying that perhaps it would be better for all concerned if they could be friends— "and no cameras will ever come into it."

The letter, written in the early summer of 1962, is quite an extraordinary document, tracing the fault lines of the modern commerce in image and art. Mrs. Kennedy was angry and frustrated that some of Shaw's most recent photographs of her were appearing all over the world and that he had asked for another shoot, this one for the cover of *McCall's*—and when she refused, he called the President. She wrote:

> You know my feelings—the last thing I need is more publicity. It is also the last thing I want. I know your answer to this is that your pictures are wonderful ones—which they are—and that is better than having bad ones. I agree—and had hoped to cooperate with you and save your pictures

for times when stories were unavoidable—i.e., the next campaign—the new baby etc.

Why do I need that picture of John and me in McCall's now—when there will be so much publicity about the new baby anyway? . . . Then you call JFK and go to see twice about a cover—and on the only free and happy day he has had lately—looking at our new house—he has to remember your deadline and call you and cancel it. I don't think the President—in these troubled days for him—should be pestered like that . . .

You told me that for a great photographer not to show his work is like asking an artist to leave all his pictures hidden in a bottom drawer. I understood that—and out of friendship for you—I agreed to the idea of your doing a book—once the Presidency was over. I agreed to that because I cared about you. The last thing I want is a book. I welcome the days when anonymity will descend. I hope we will be quickly forgotten . . .

Why do you press us so? . . . We have been rammed down everyone's throats so much that I don't care if the greatest photographs in the world appear—it just offends people—they are sick of us . . . I remember—though I was interested in her—how sick I got of Princess Grace and thought how in bad taste it was to let herself and her children be plastered over every magazine. It was probably no more her fault than it is mine . . ."

Mrs. Kennedy told Shaw she knew his pictures were better—"great," she wrote—but the issue was not art but control. She intended to supervise photo sessions with her children and control the release of their photographs. "As long as I am there, I will feel safe. It is just when I don't know about it and a Stan Tretick sets up a shot of Caroline plastered with Kennedy buttons that gives me nightmares—and that will never happen again."

Jacqueline Kennedy and Mark Shaw did remain friends until his death in January of 1969 at the age of 47. There was more than the usual sadness in that. Shaw's death,

officially listed as from a heart attack, was related to his addiction to amphetamine concoctions supplied by a New York physician named Max Jacobson, who eventually lost his medical license. Shaw's book, *The John F. Kennedys: A Family Album*, a best-seller in 1964, was dedicated to "My friend and companion Dr. Max Jacobson."

Dr. Jacobson also supplied amphetamines to both the President and Mrs. Kennedy, sometimes being flown from New York to Washington by Shaw, an accomplished pilot with his own twin-engine Cessna. The physician made more than thirty recorded White House visits in 1961 and 1962, a period before amphetamines were classified as controlled substances, and he was a member of the official American party travelling with President Kennedy to Vienna for his summit meeting with Soviet Premier Nikita Khrushchev in 1961.

Of course there is now more sadness and irony in the friendship of the brilliant young photographer and the dazzling young couple he was able to capture forever. The photographs can rip at your heart and so can some of the lines of correspondence between Jacqueline Kennedy and Mark Shaw. During the 1960 campaign, when her husband was still a senator and when everything was possible, she wrote thanking Shaw for some photos and a working cut of an album Pat Suzuki was recording at the time:

> You are an angel to send those beautiful pictures—contacts—and Pat's record—which I am playing tonight by myself— My Funny Valentine is on right now and I can tell you it is the worst possible music to answer campaign mail to . . . I just hope the days will come soon when we can all have a marvellous Portofino weekend and everything she and you remind me of— la dolce vita— can happen again!— with dear Jack— who just has to win— so keep your fingers crossed— If he does it will be due a lot to you— as every time I look at your pictures again I realize how incredible they are. Will you come and photograph me and new baby? — even if he isn't in the White House.

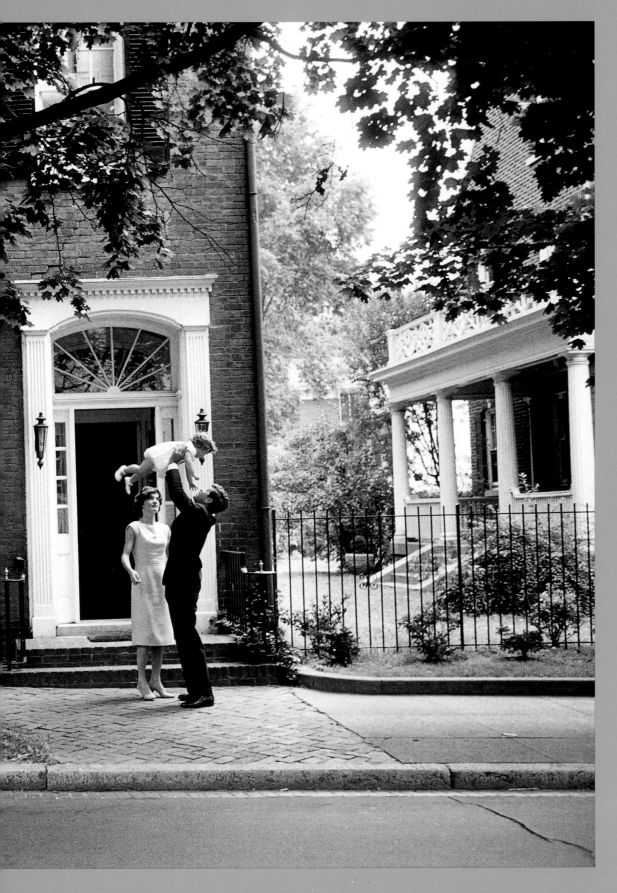

Georgetown

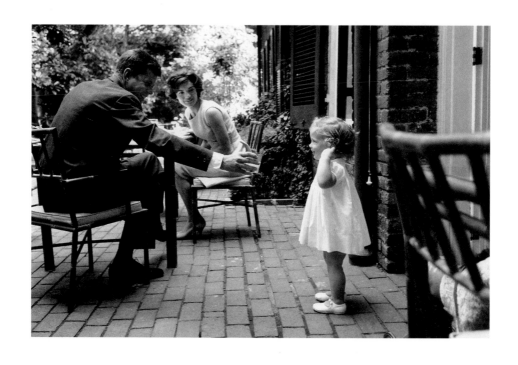

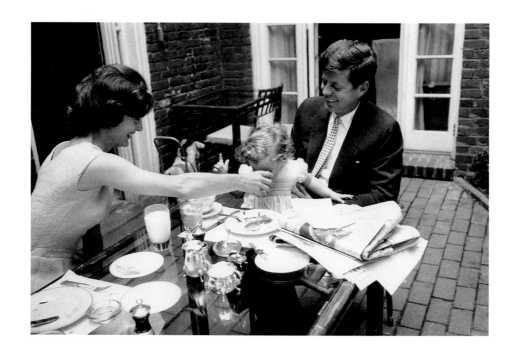

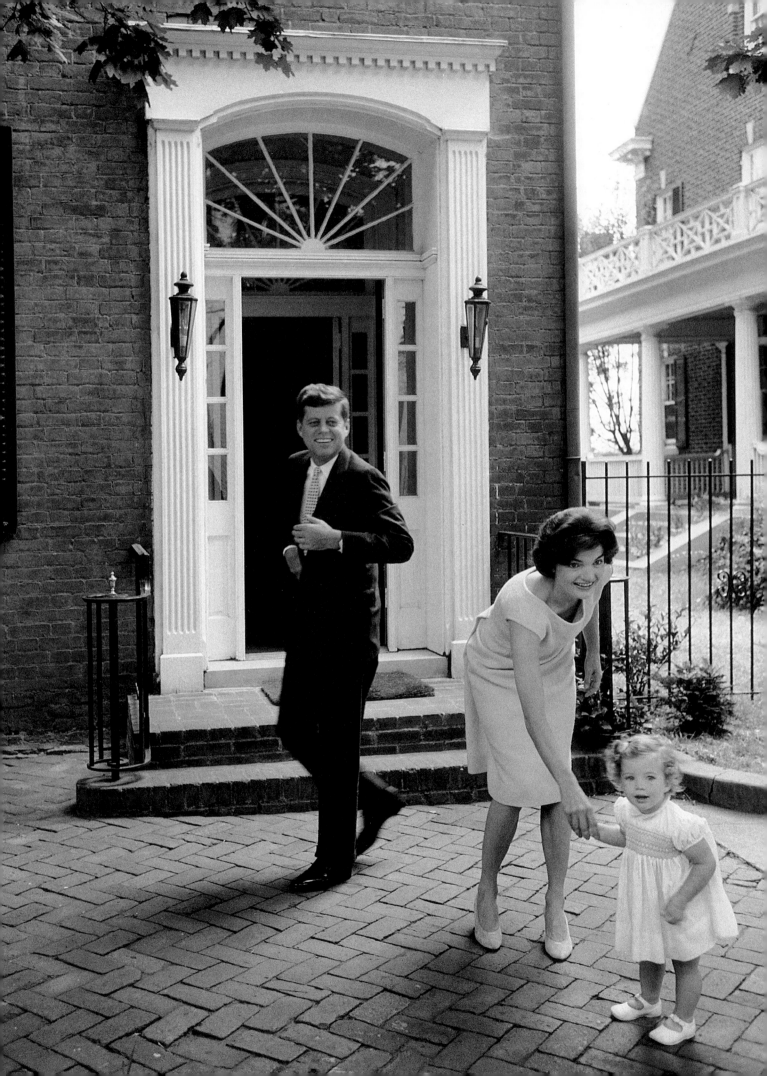

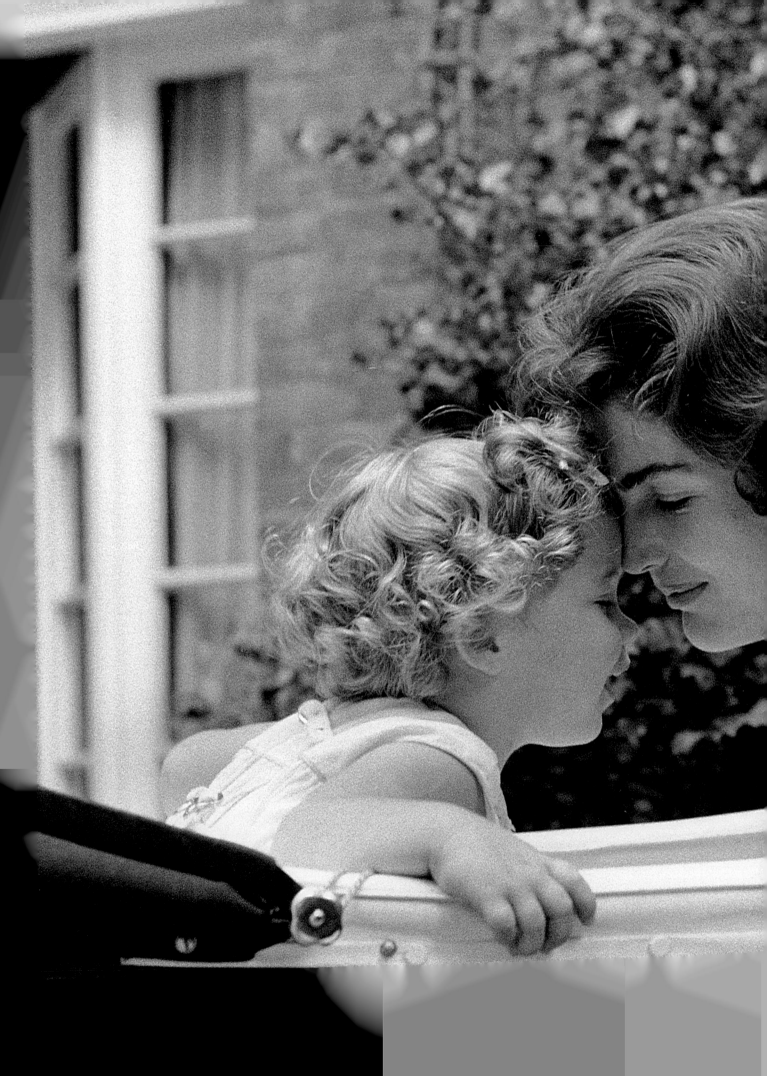

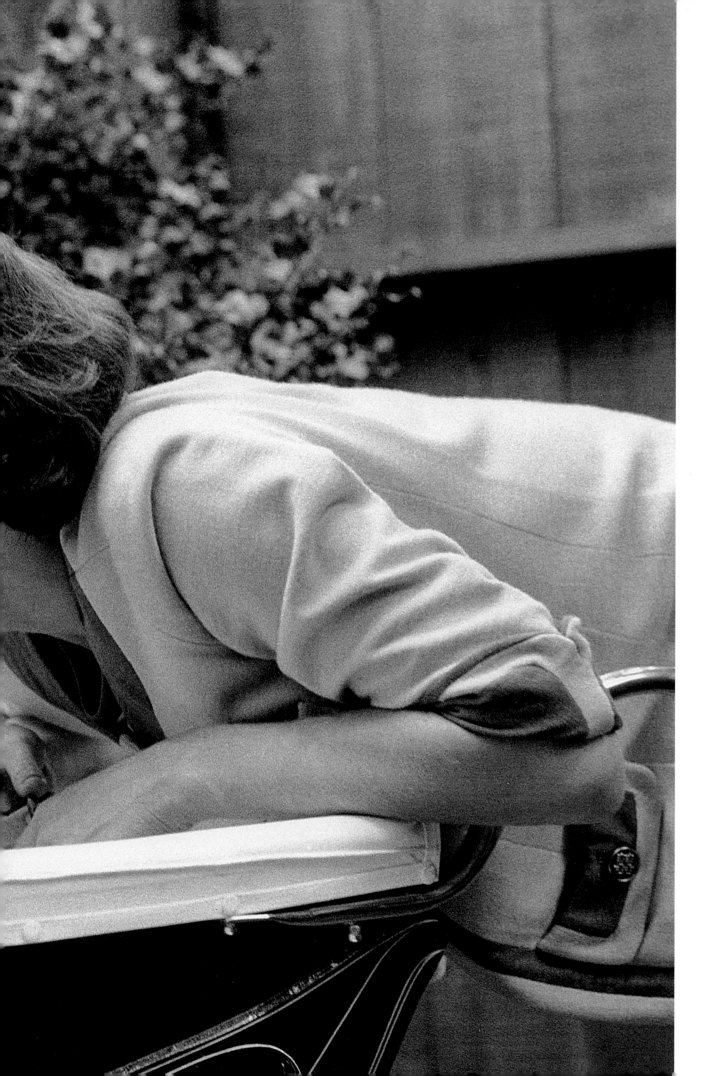

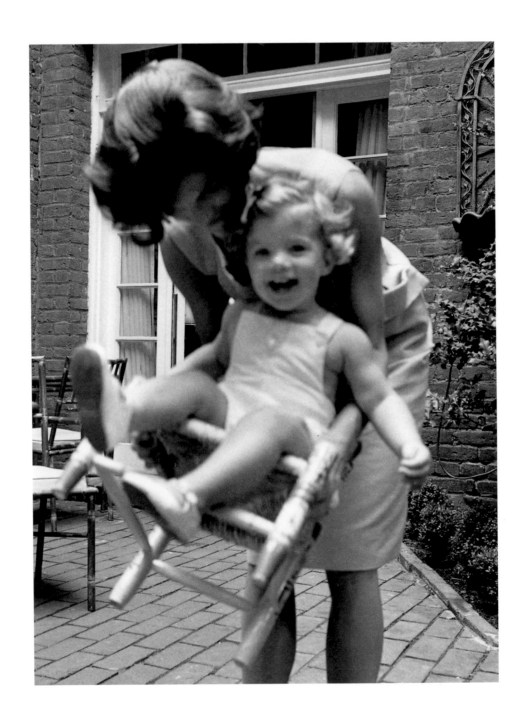

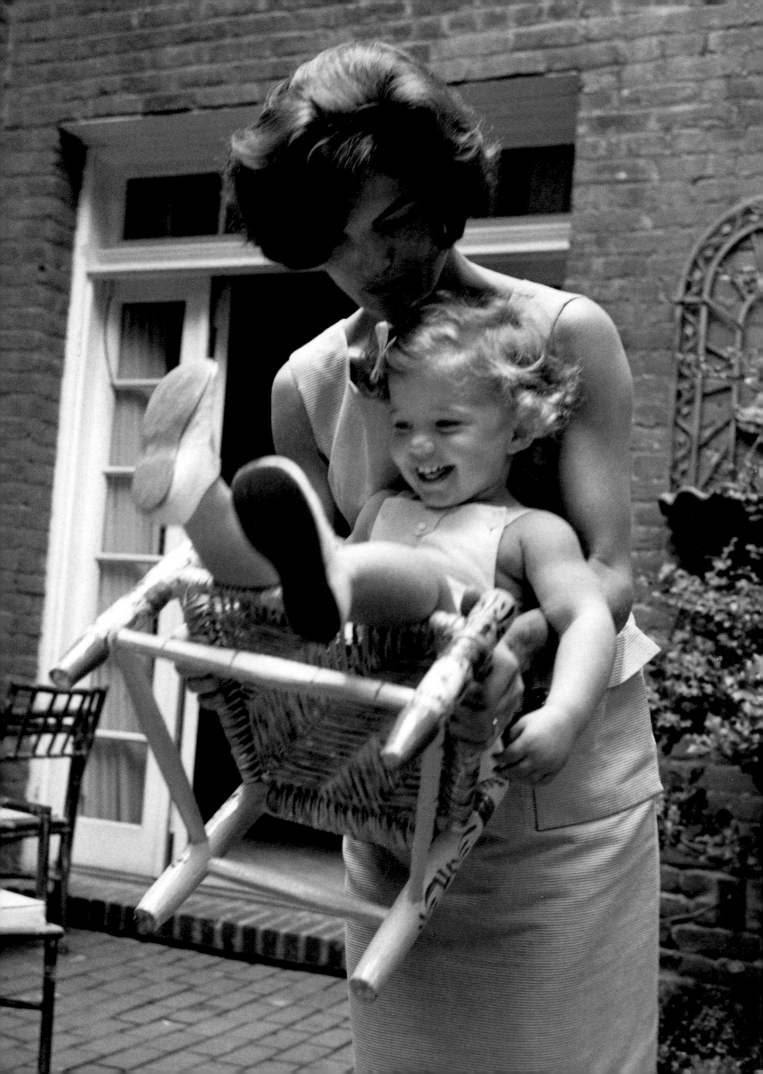

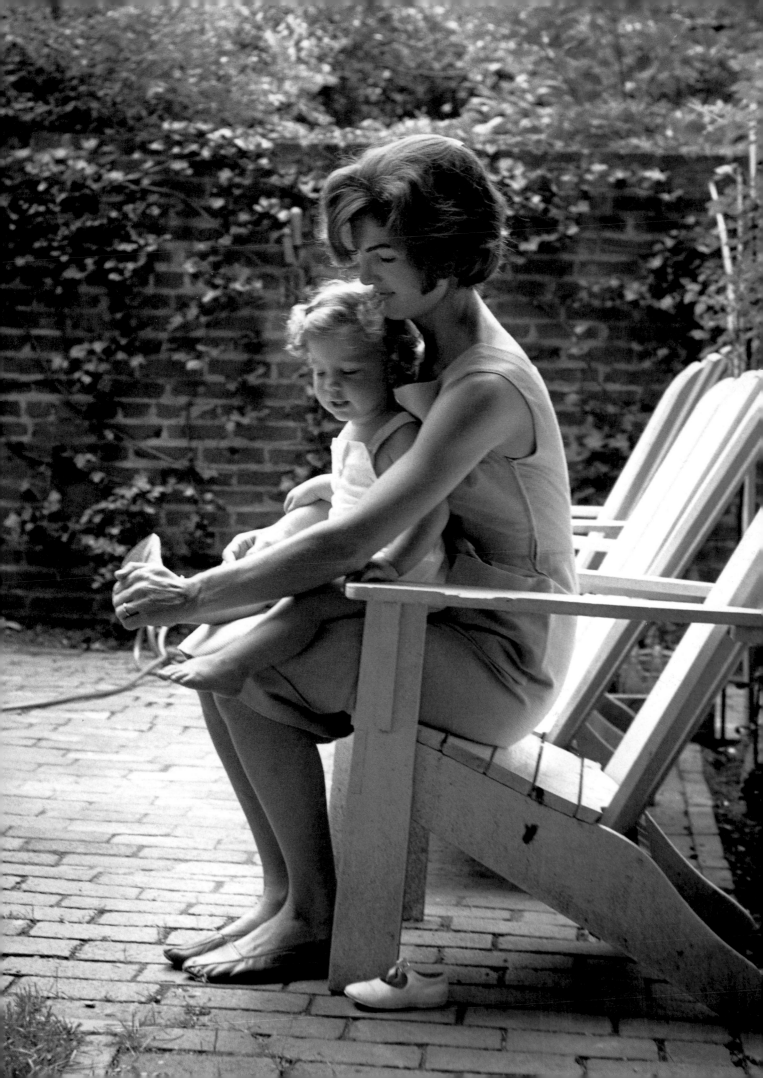

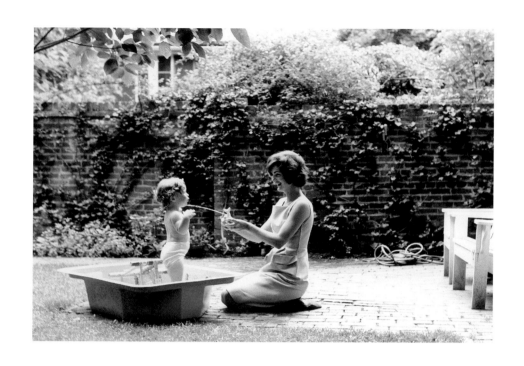

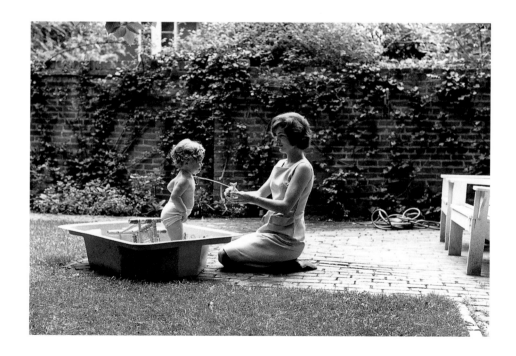

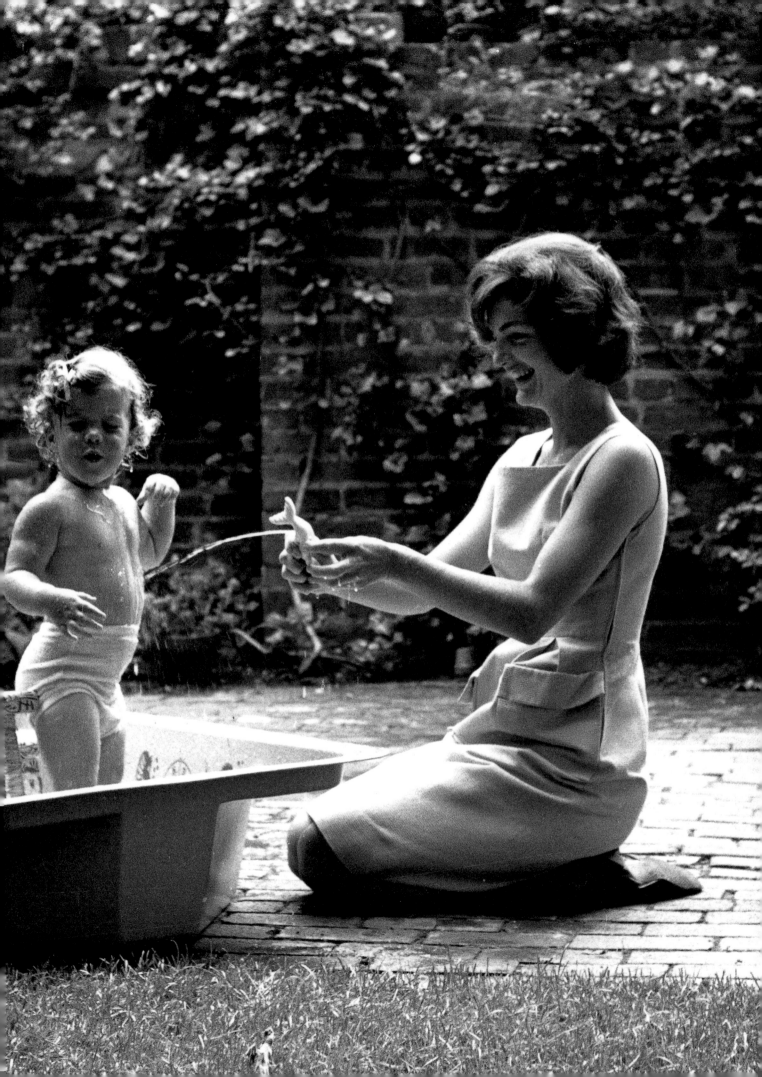

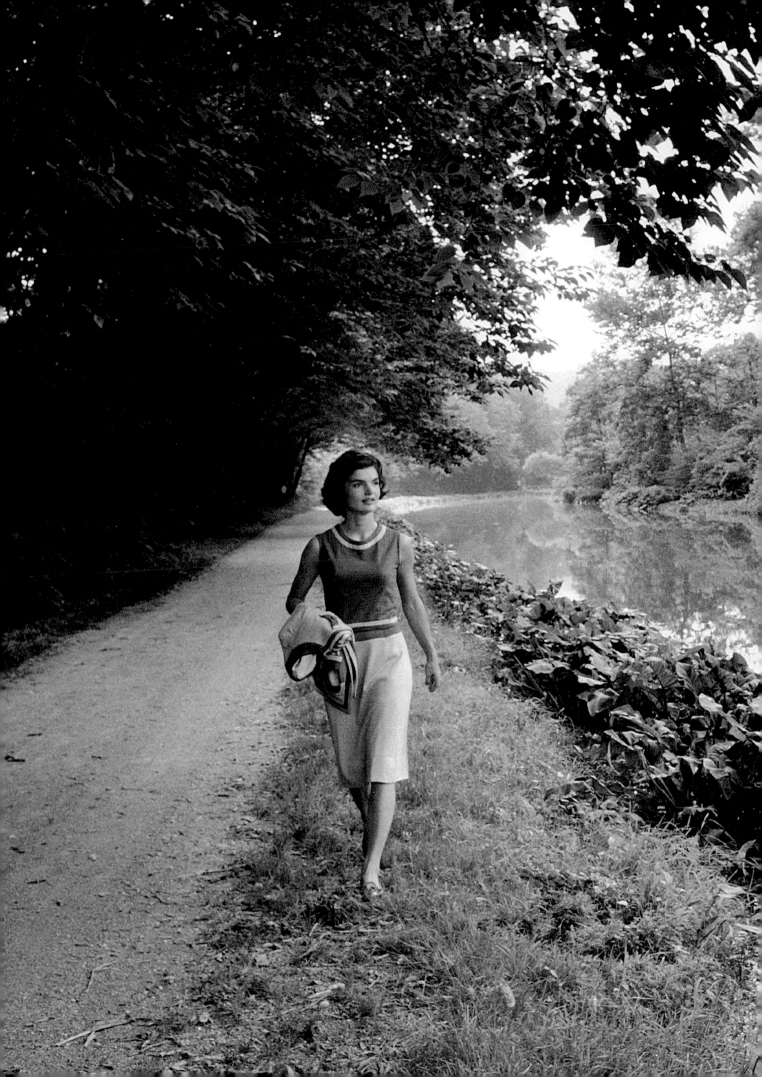

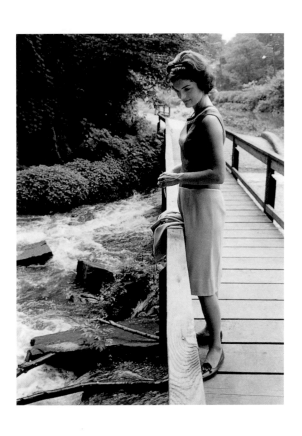

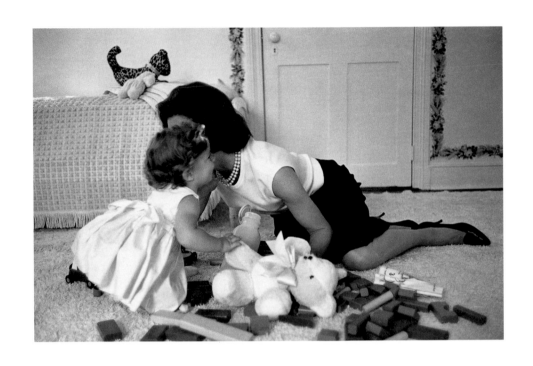

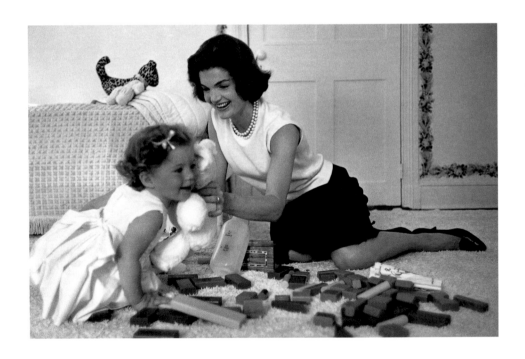

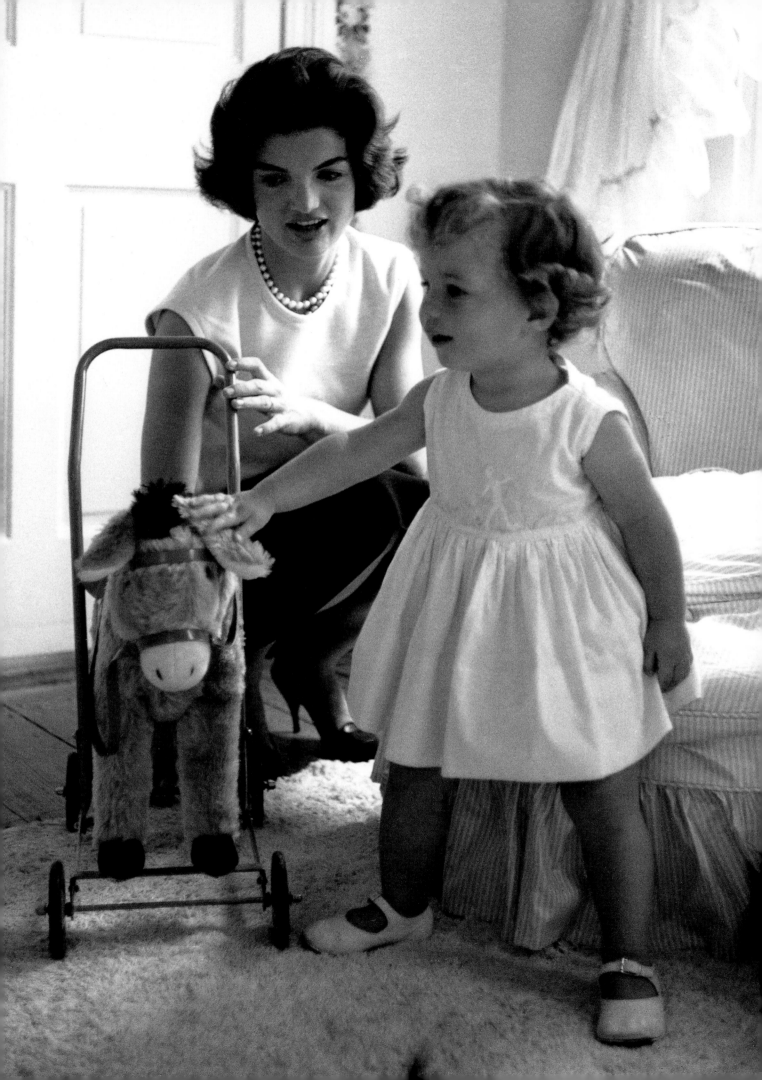

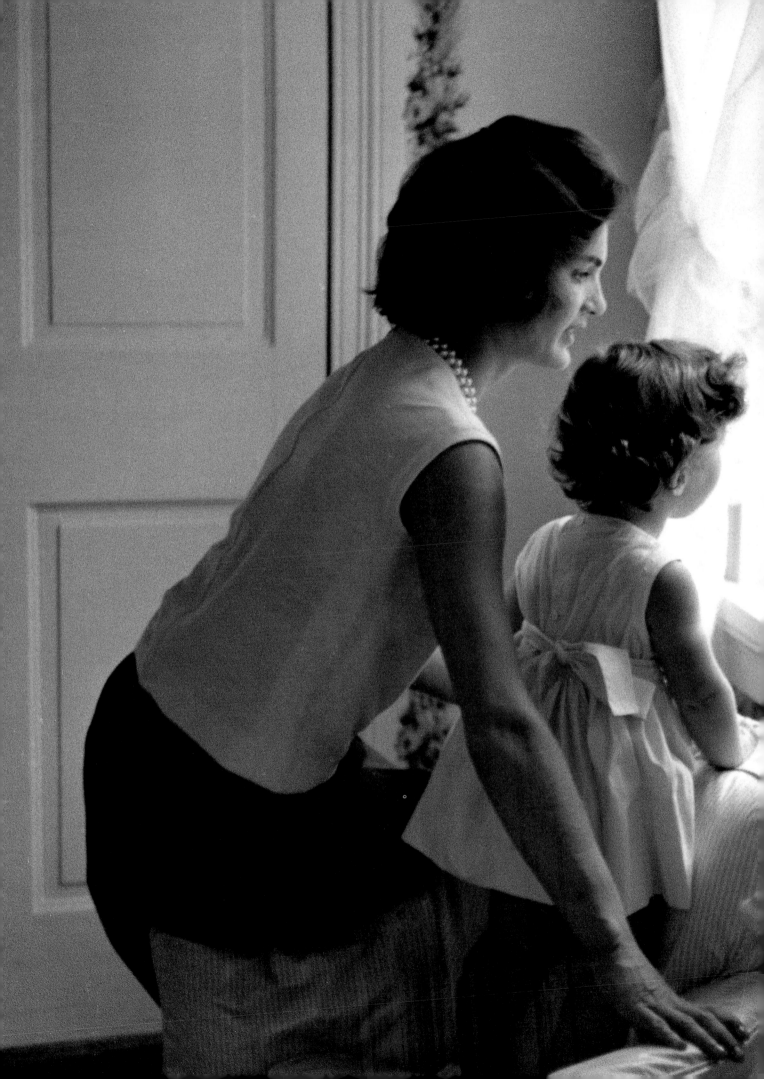

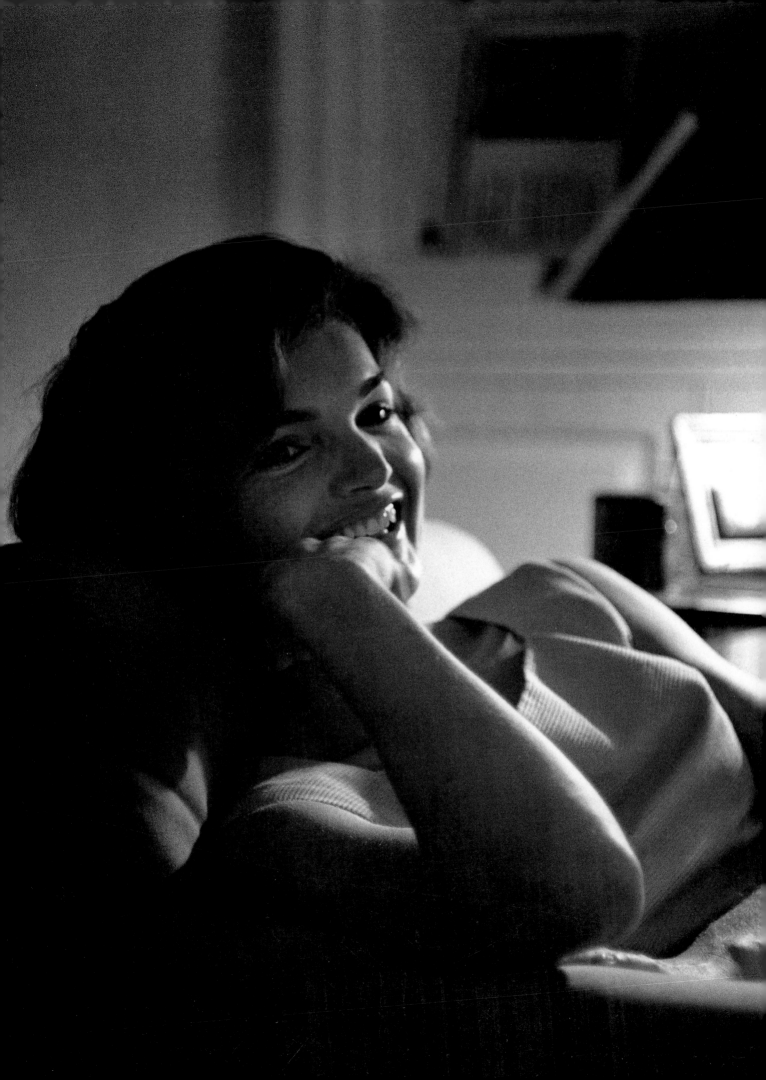

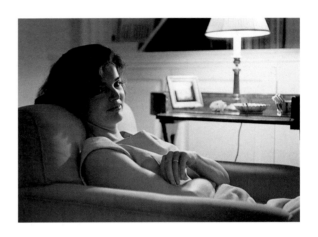

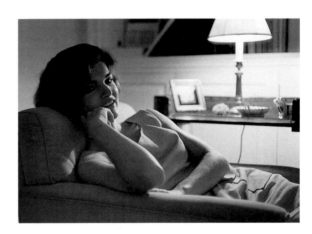

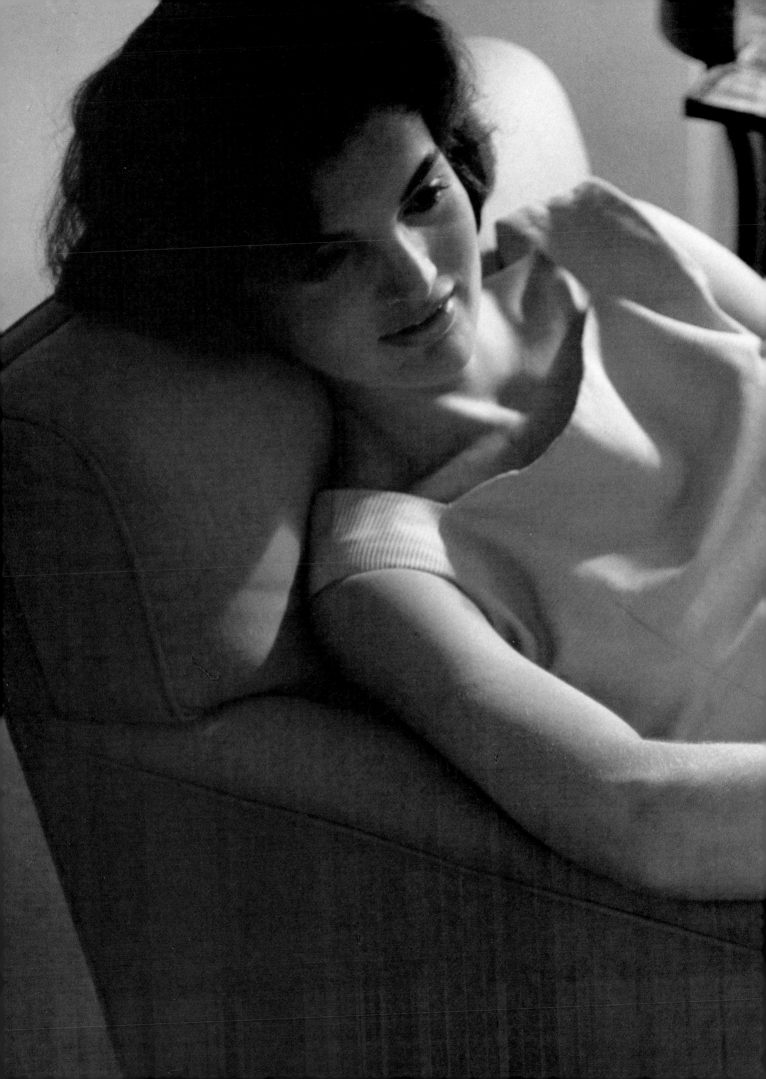

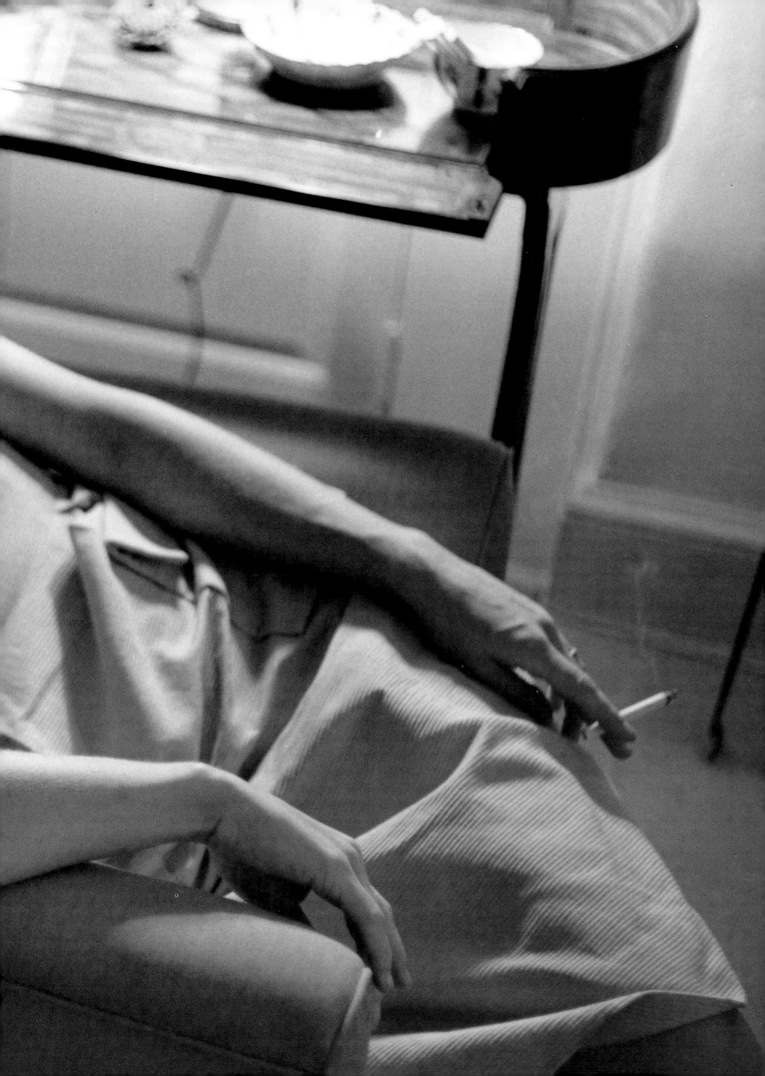

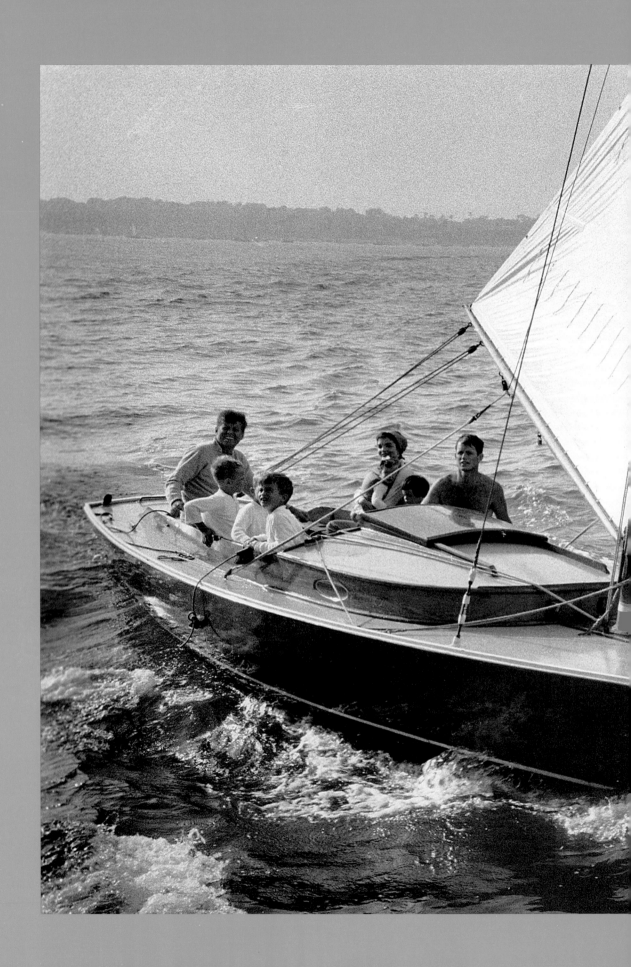

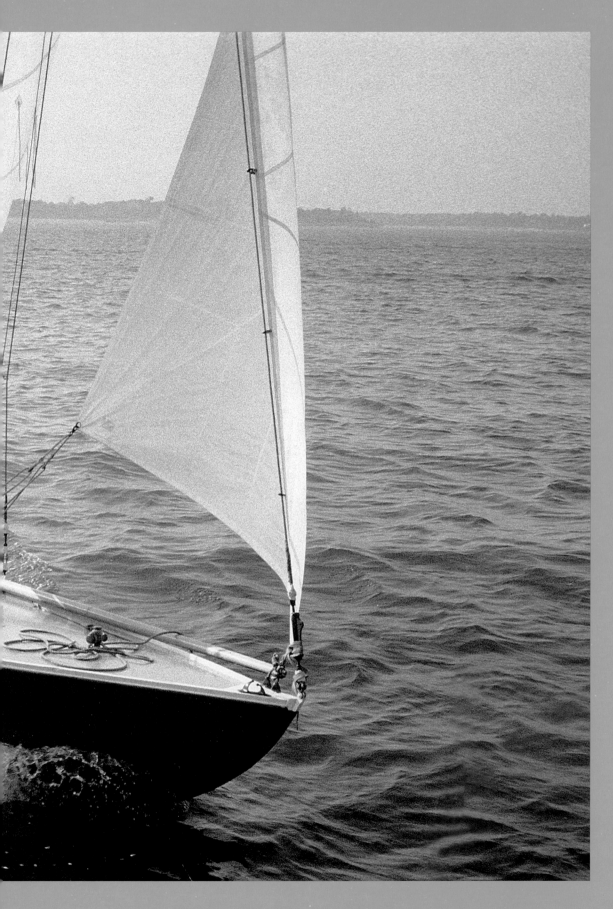

Nantucket Sound

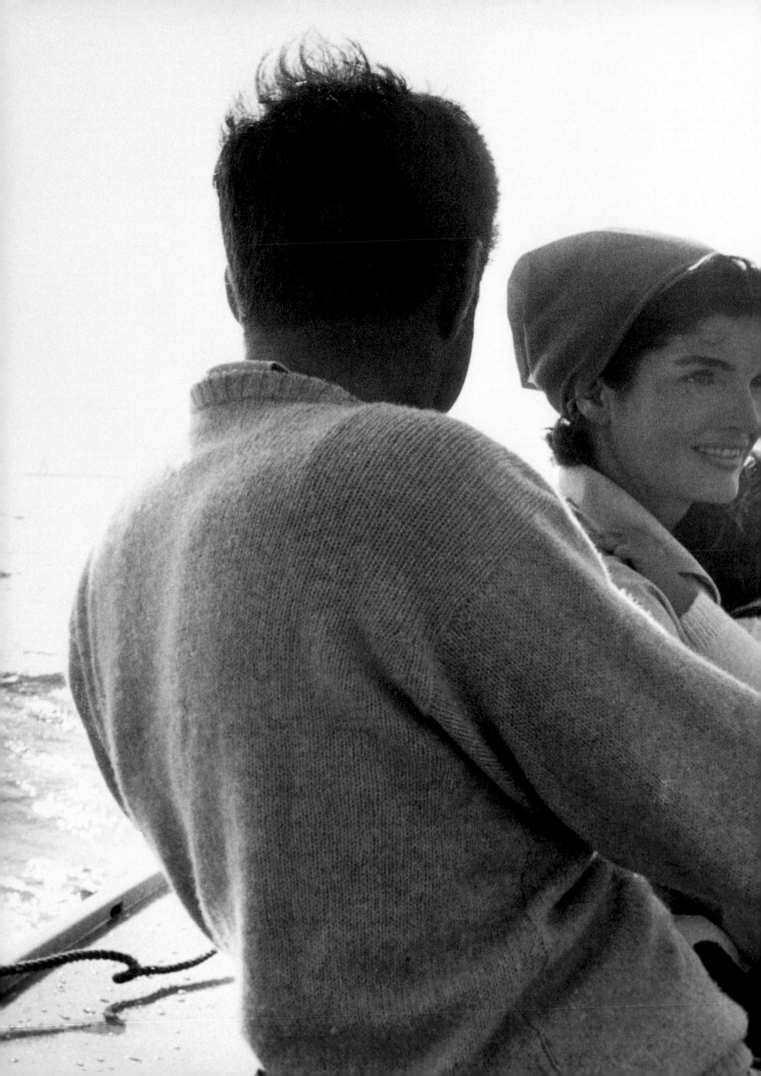

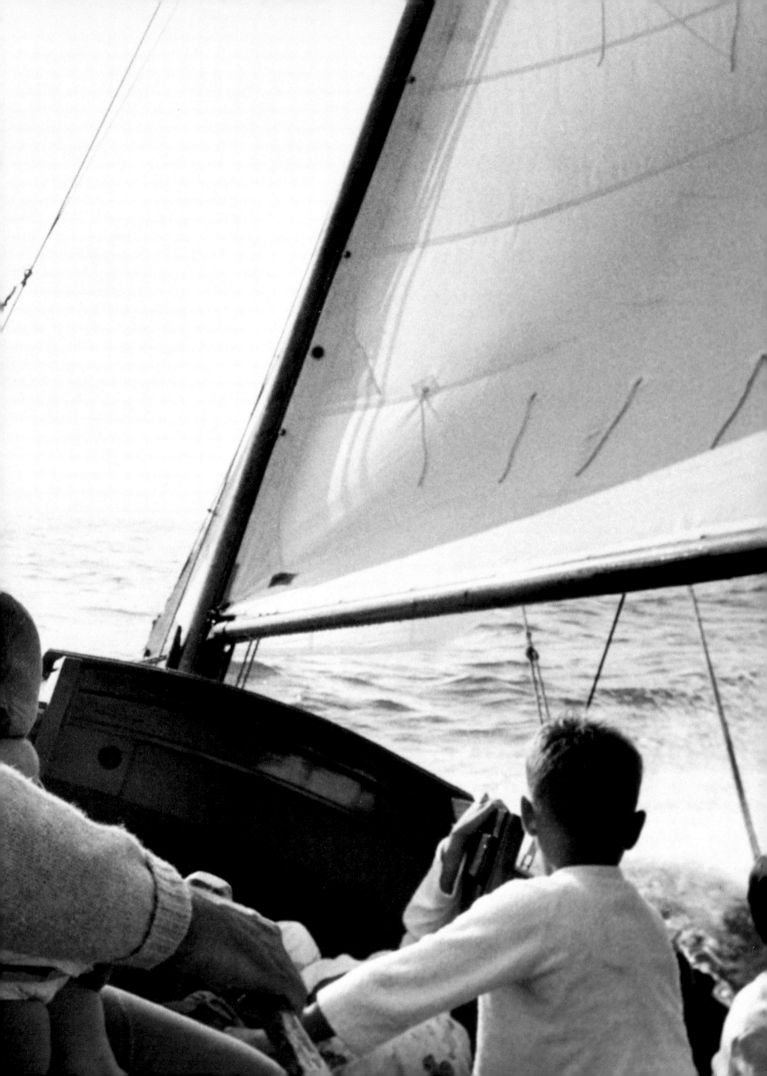

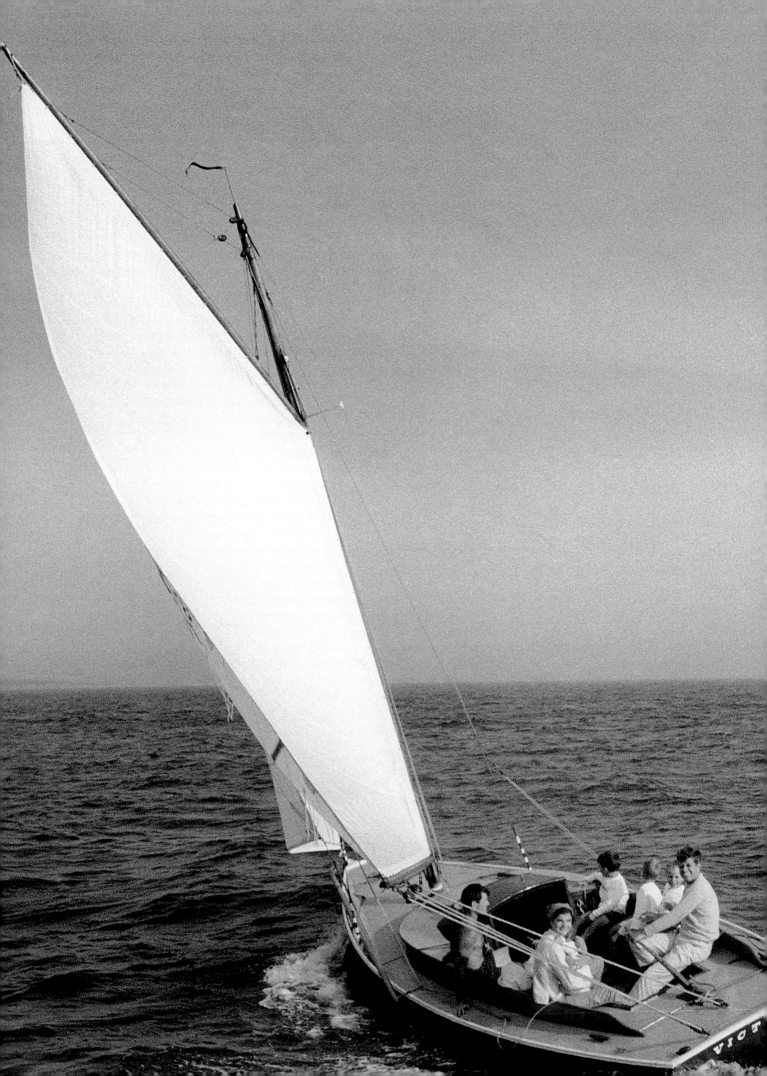

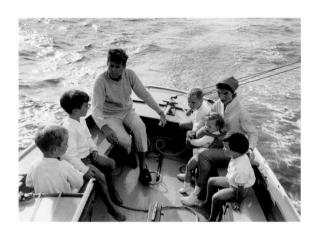

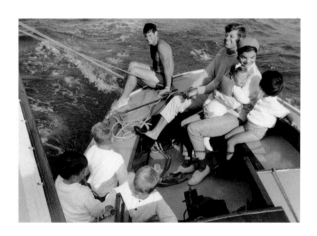

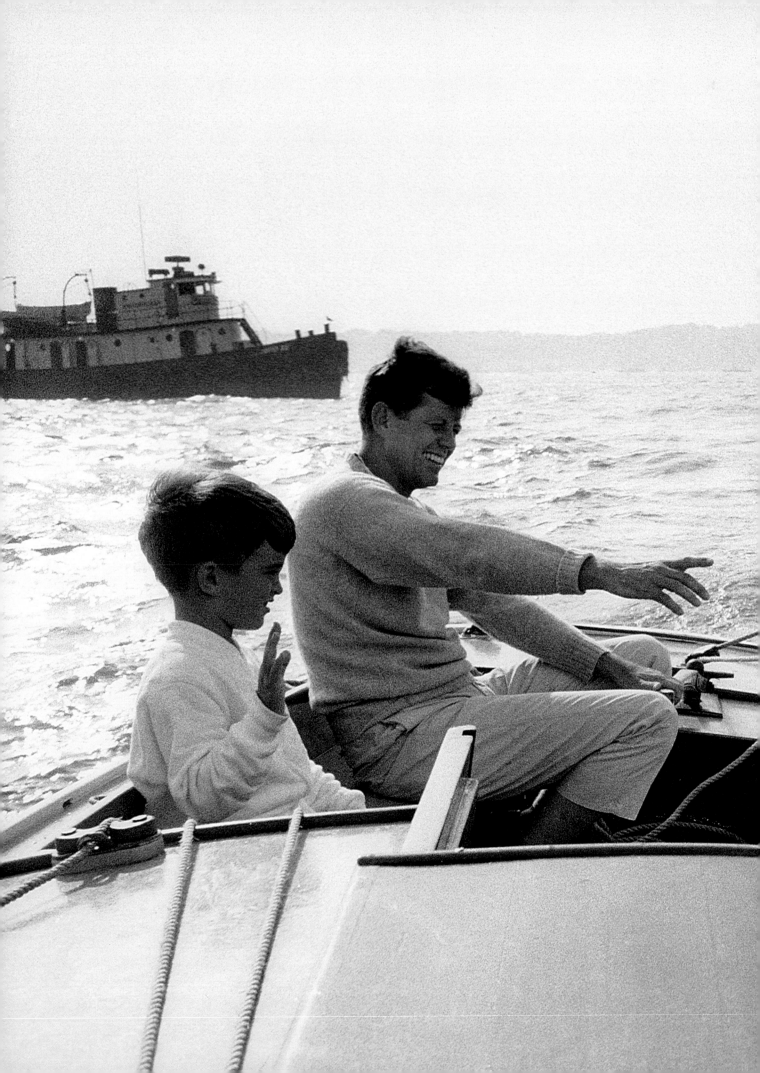

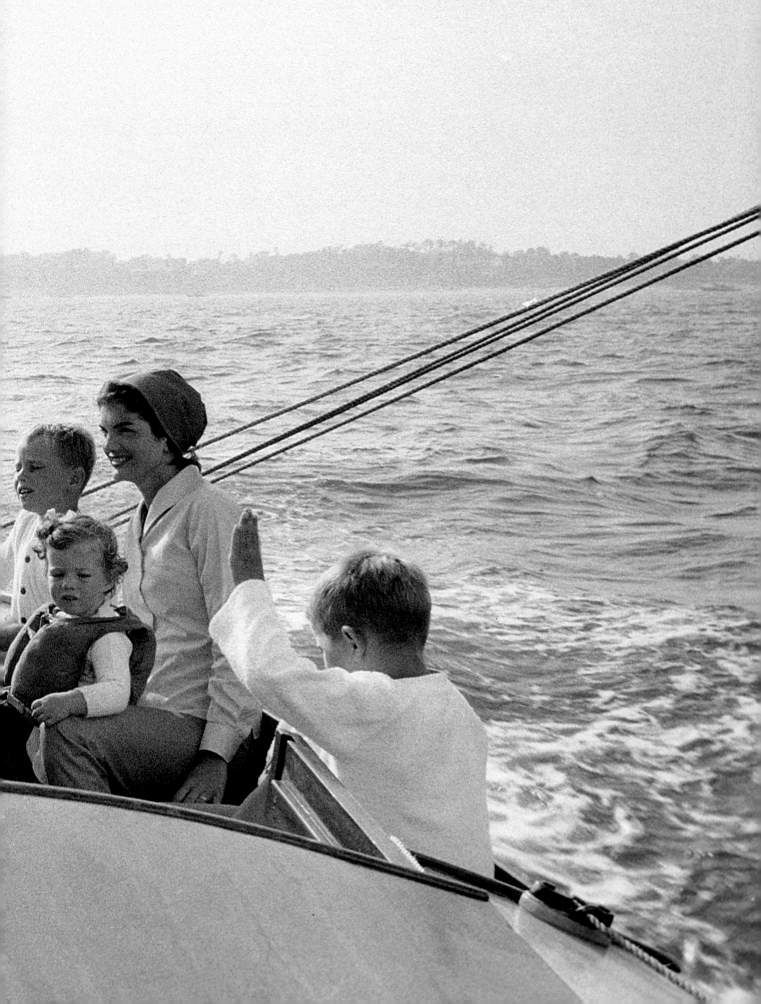

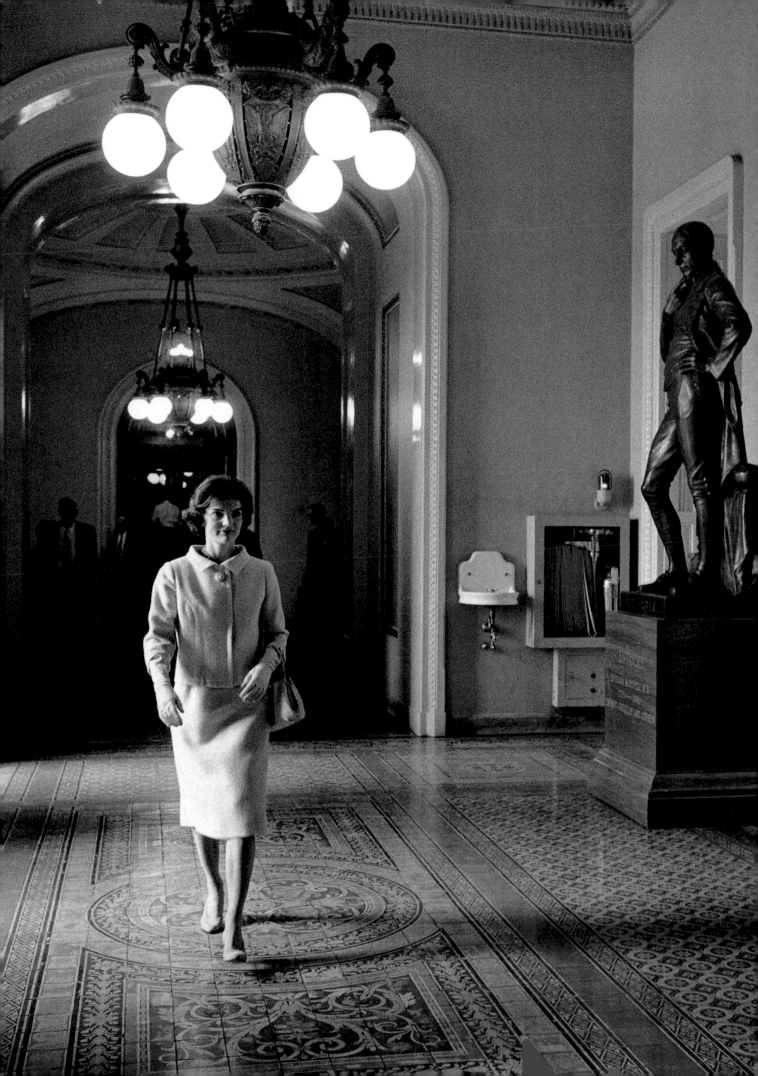

Washington, D.C.

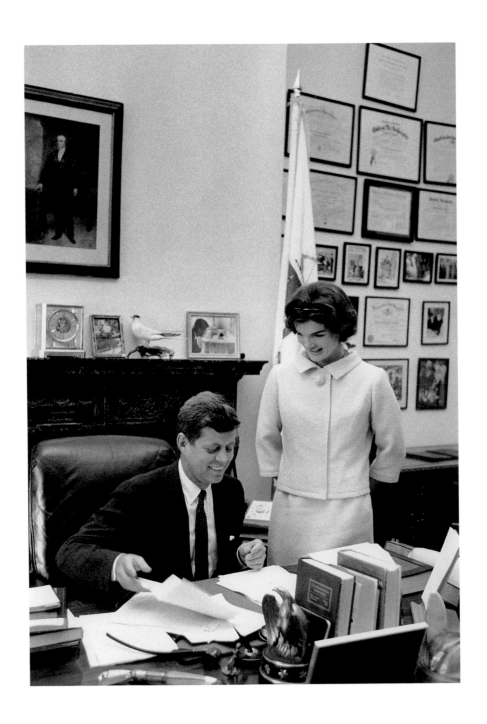

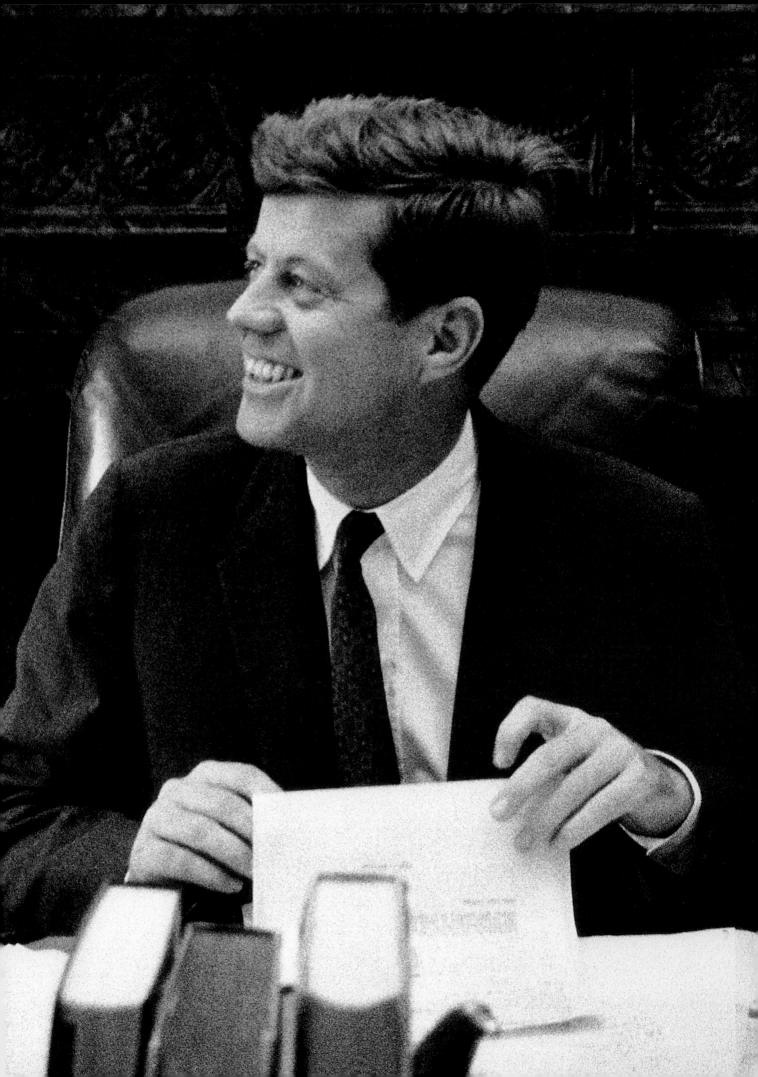

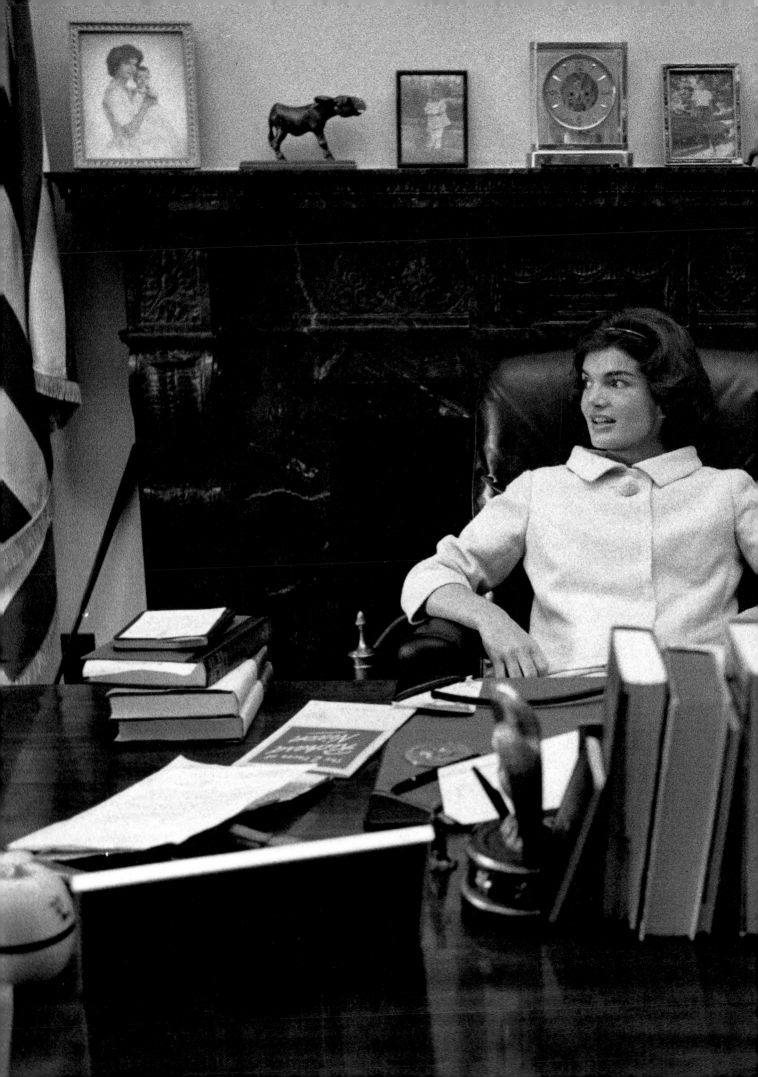

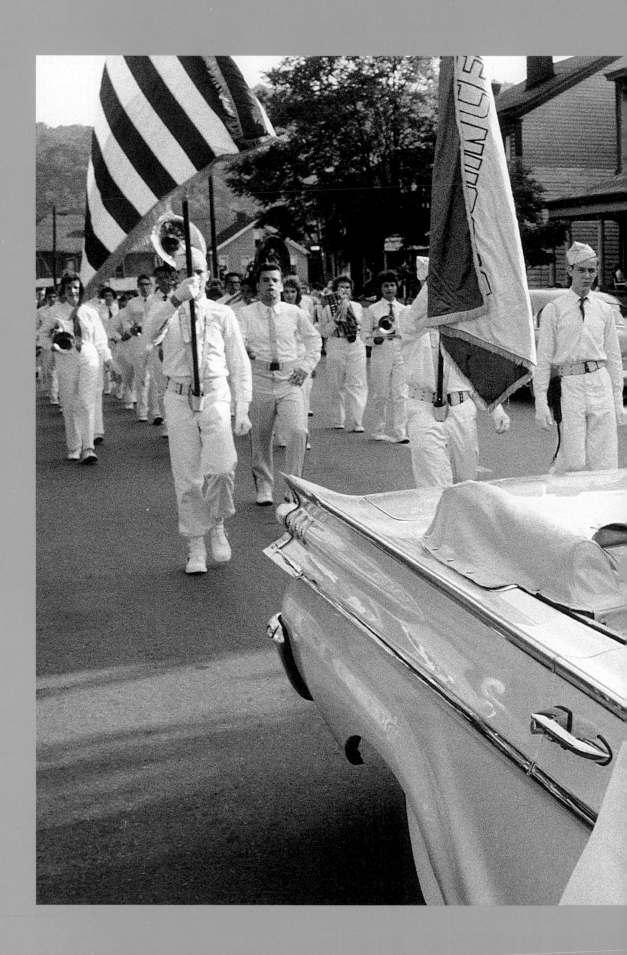

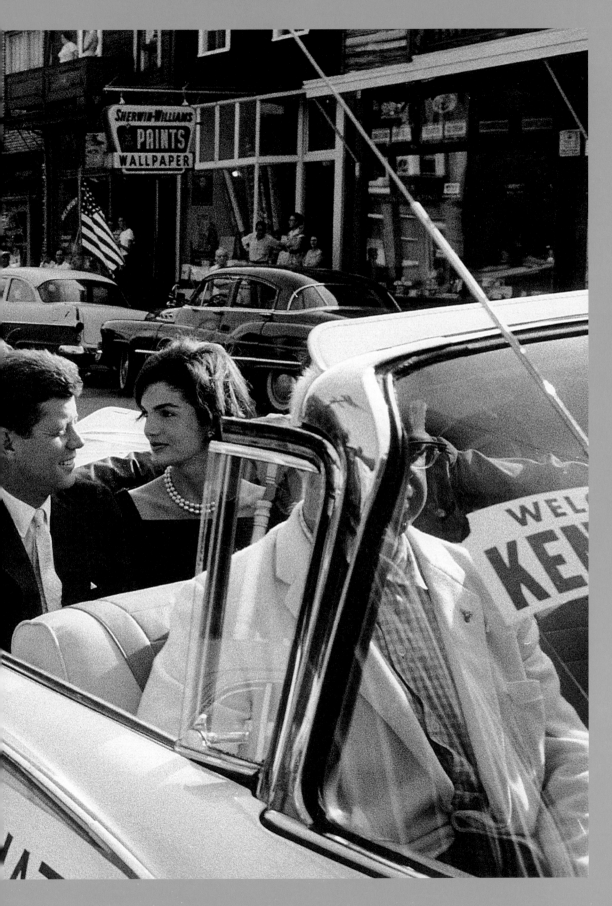

Wheeling, West Virginia

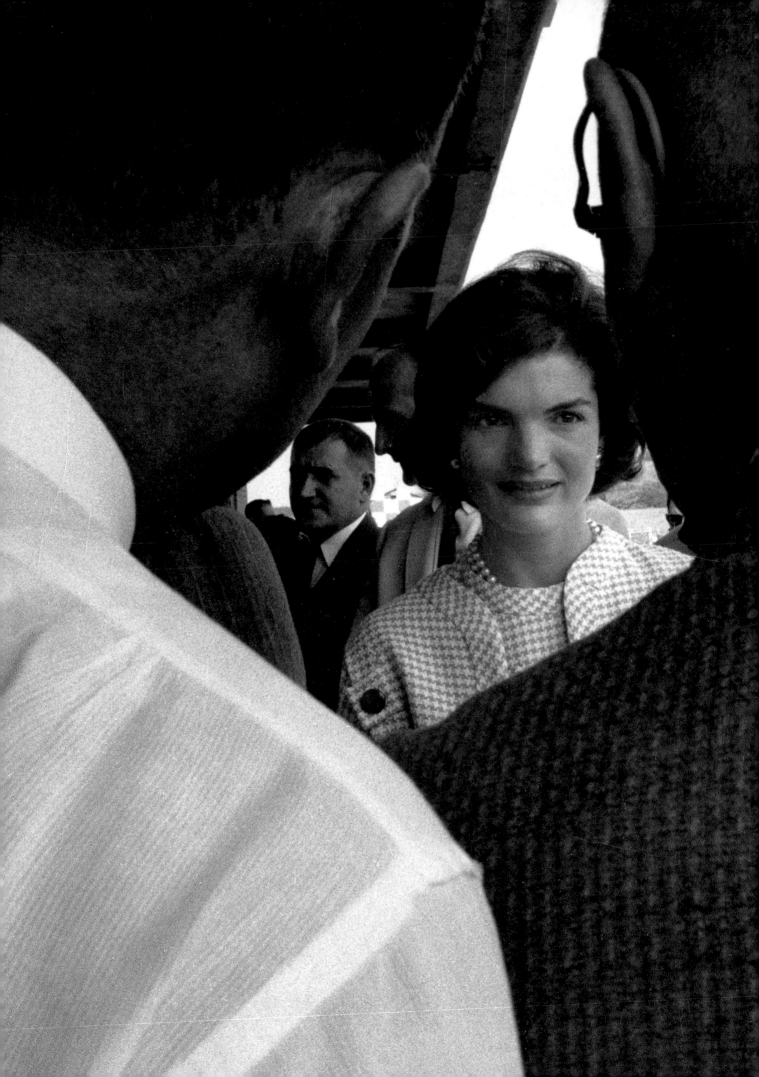

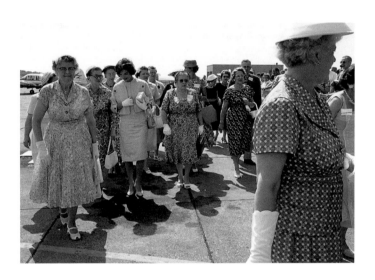

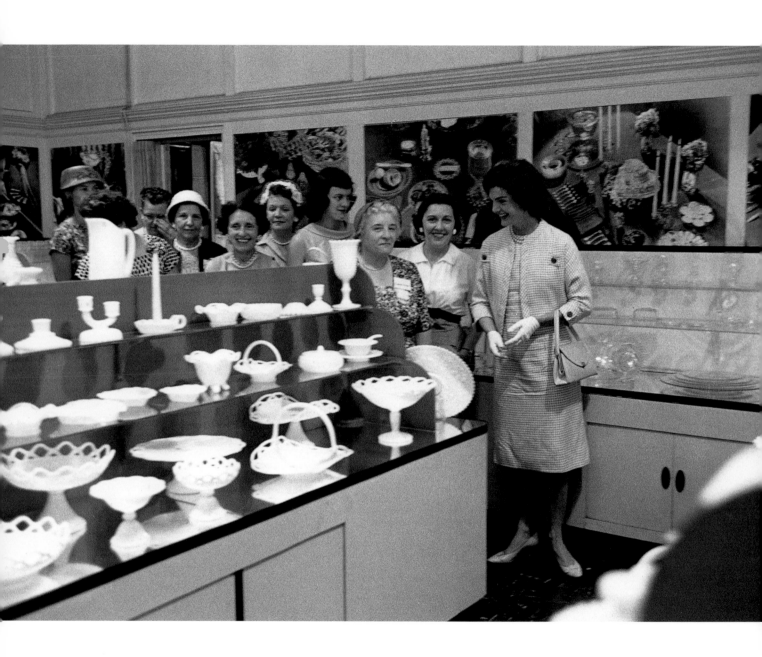

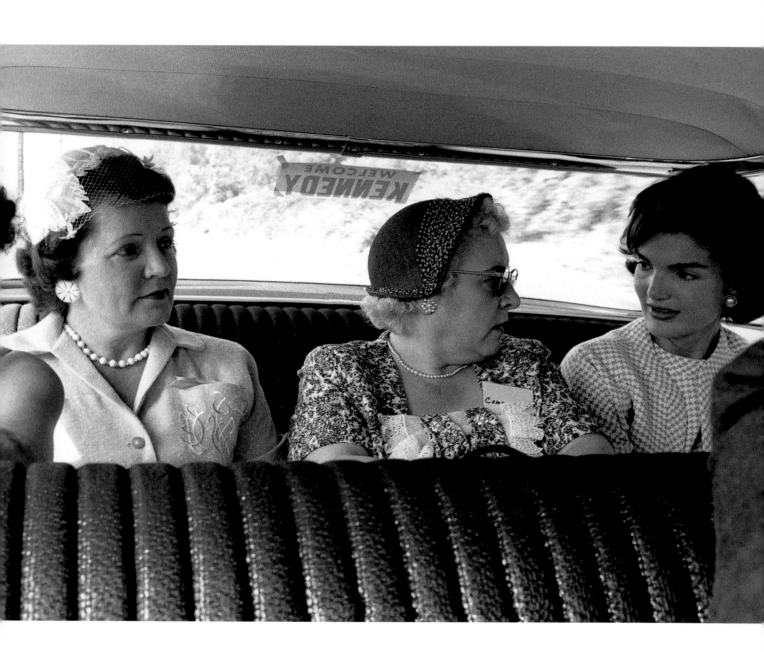

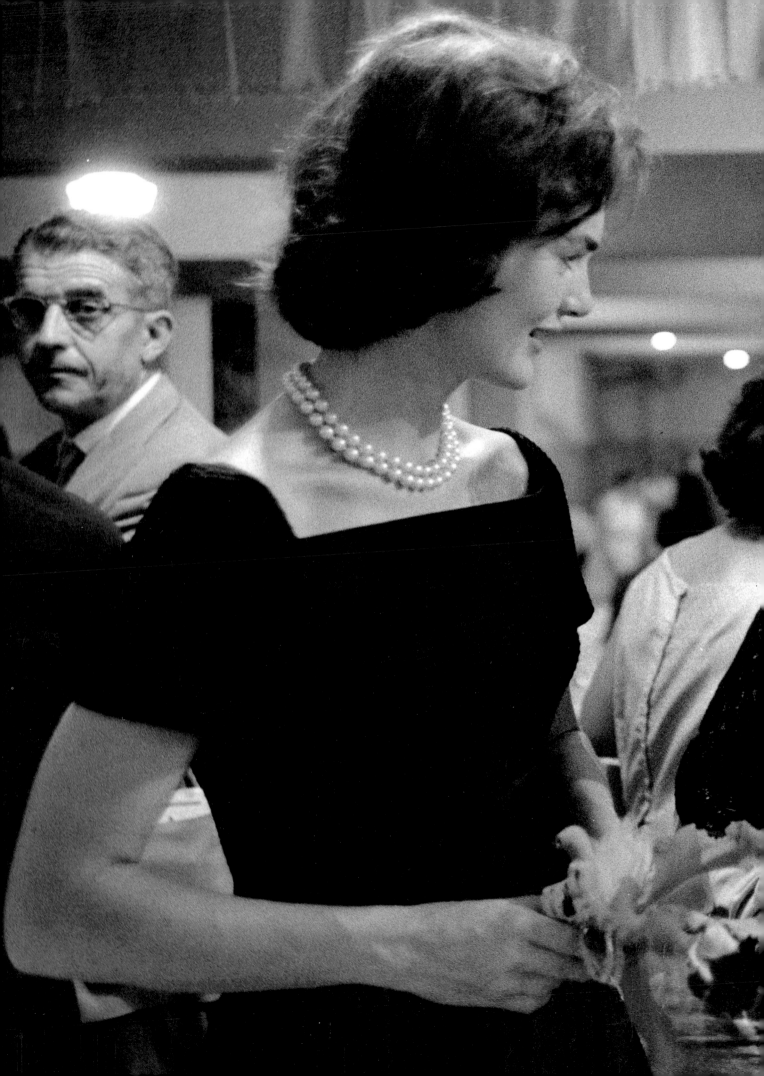

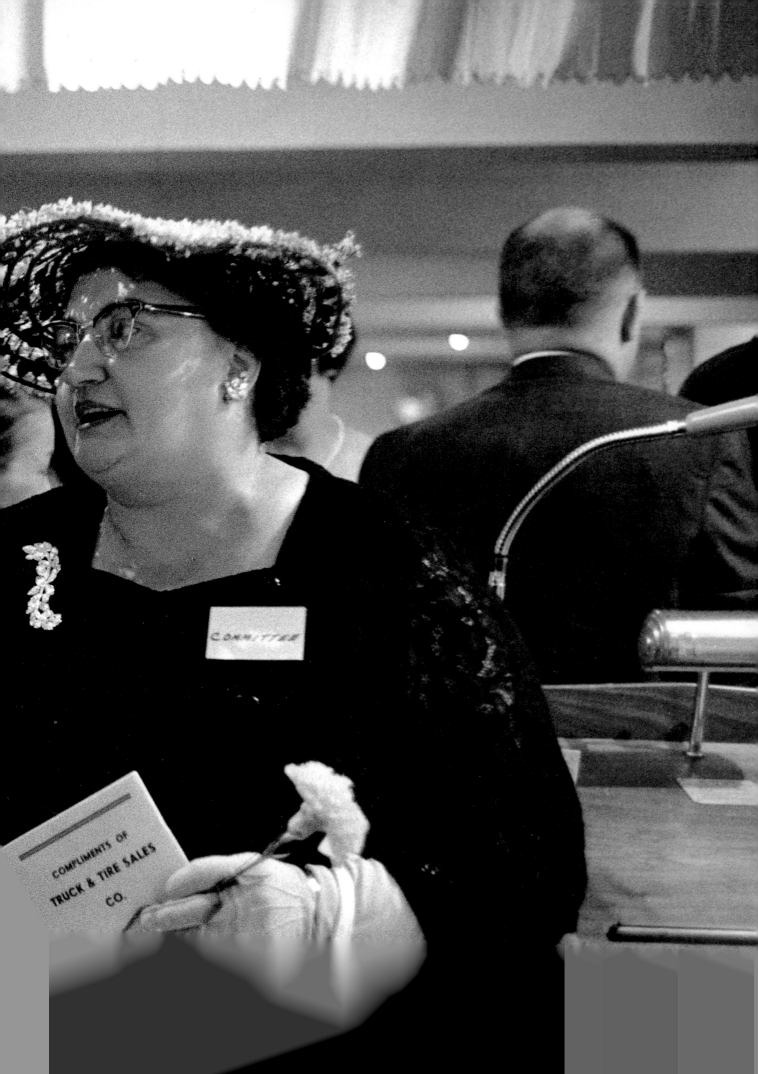

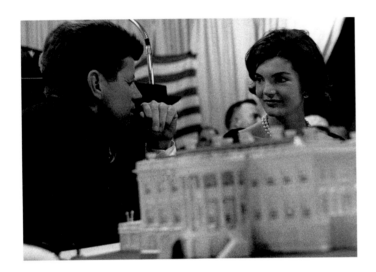

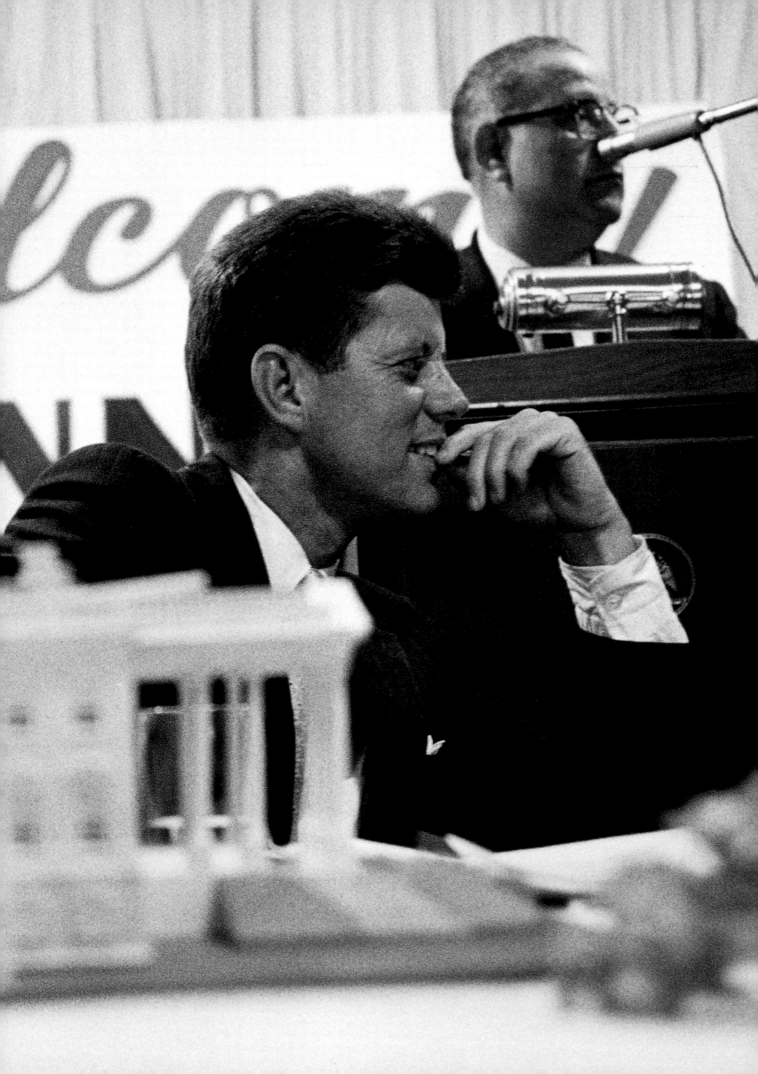

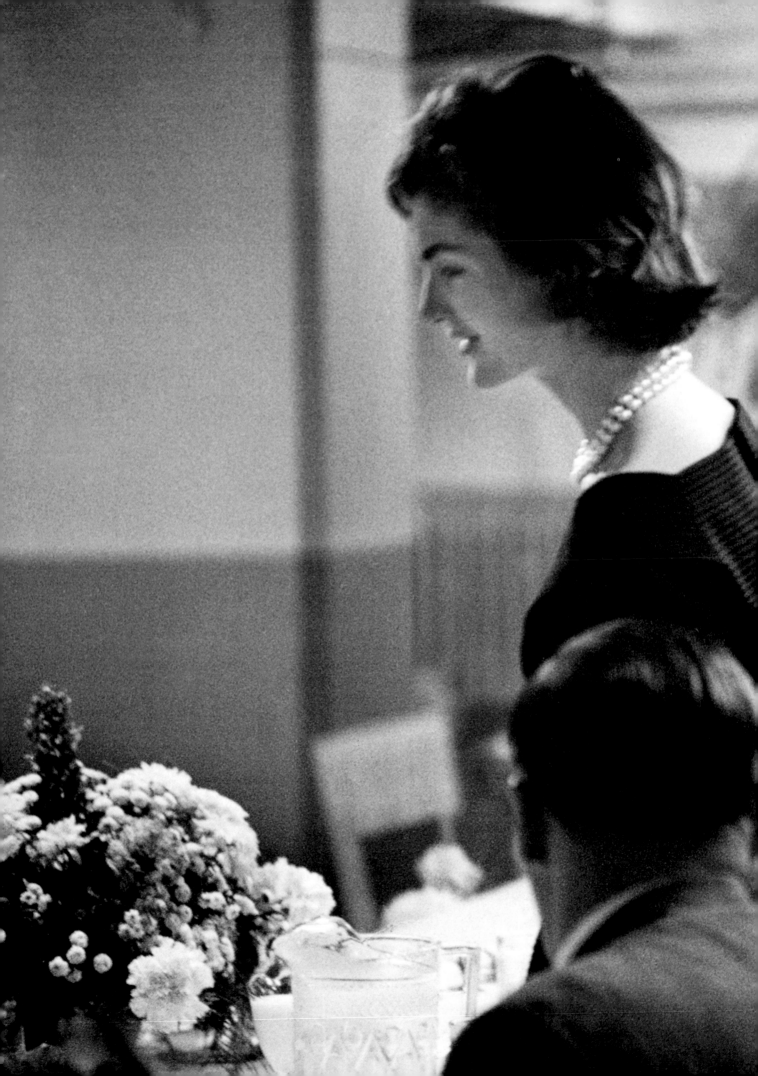

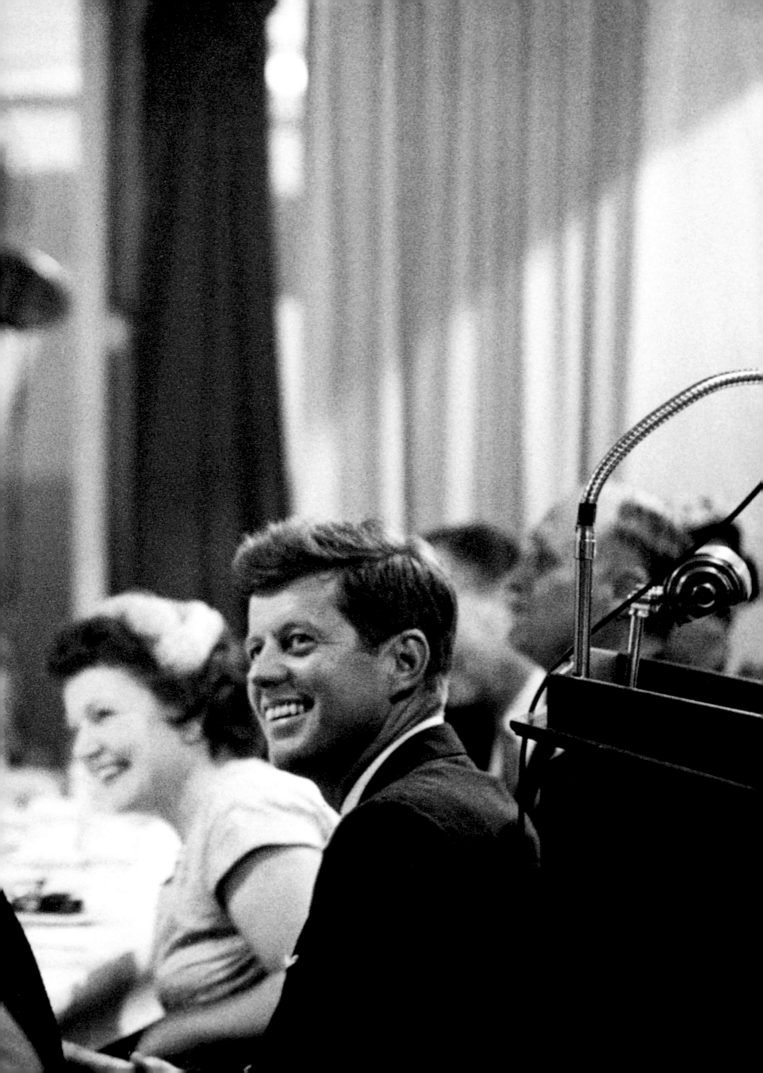

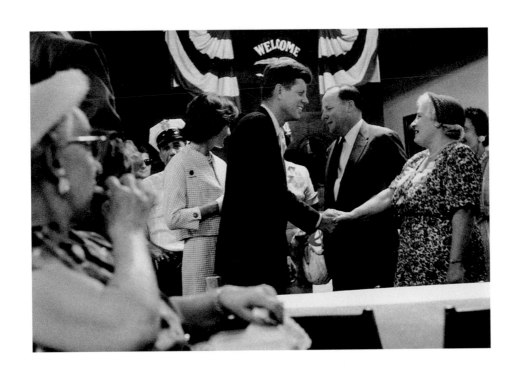

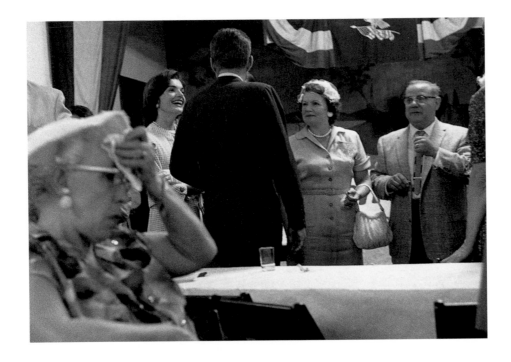

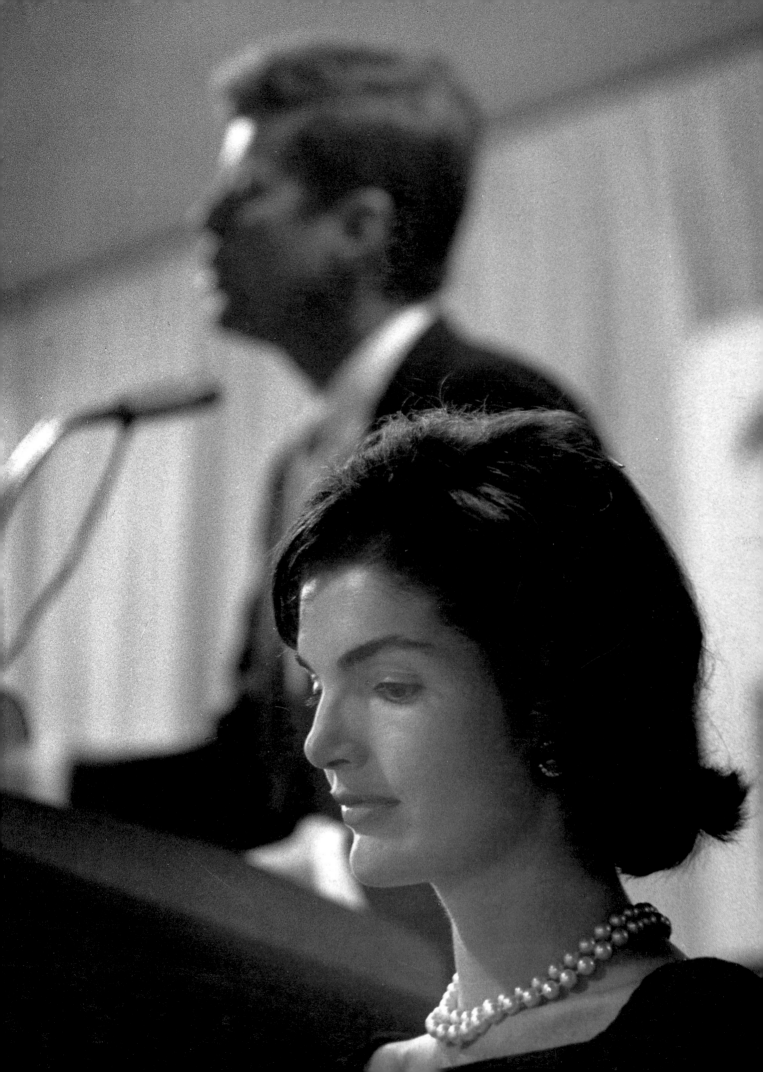

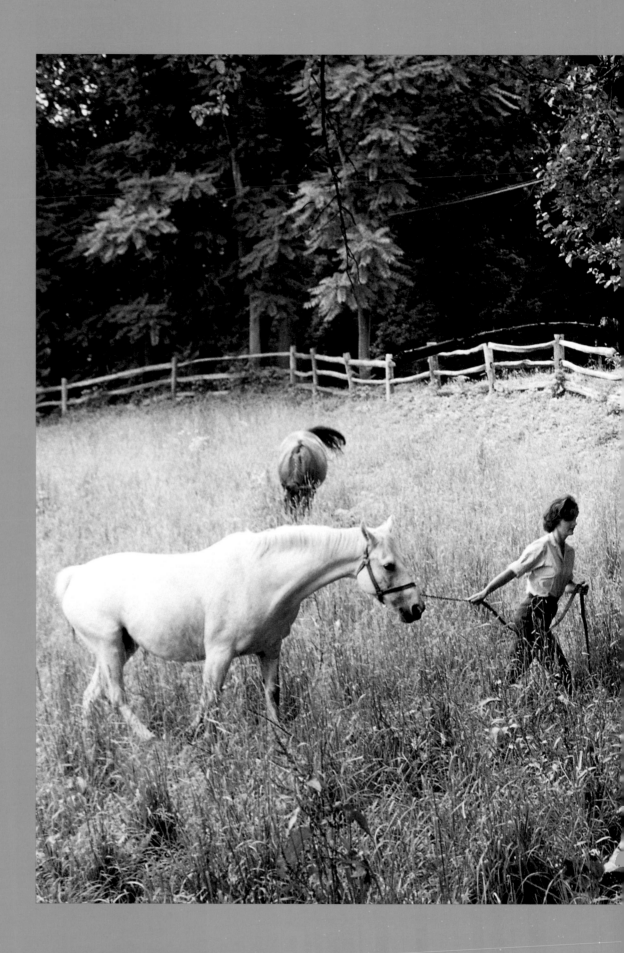

Virginia

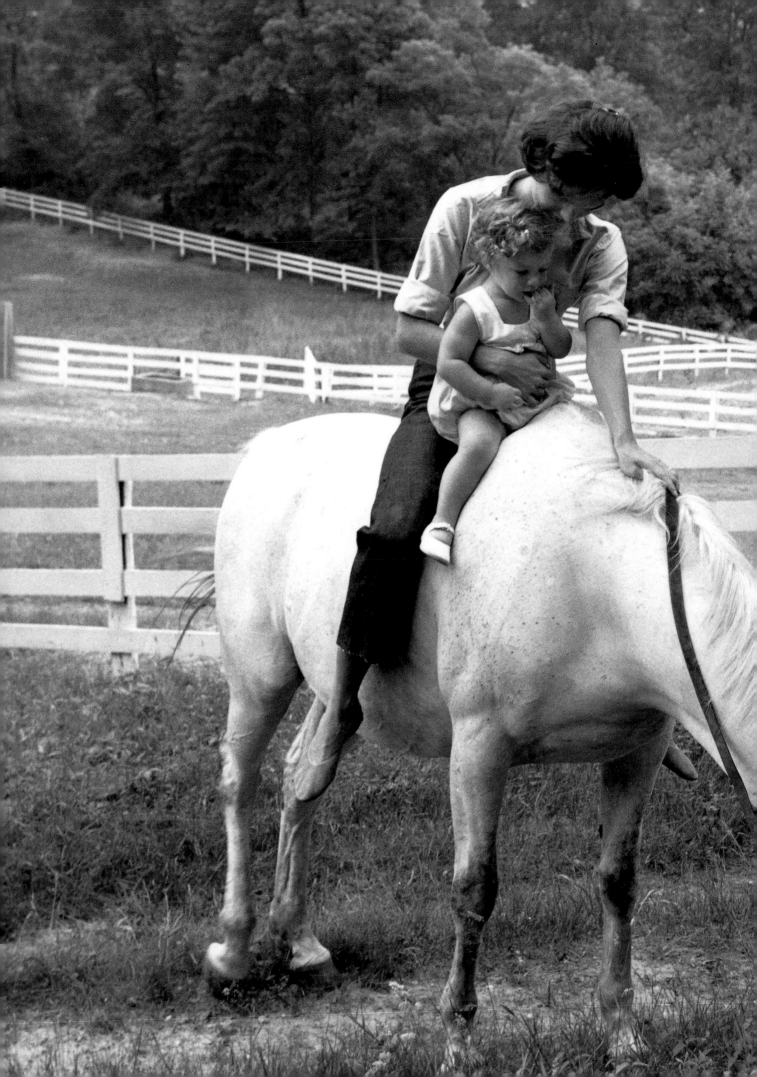

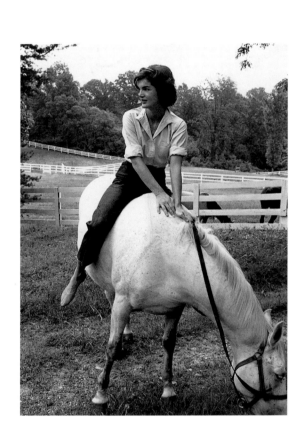

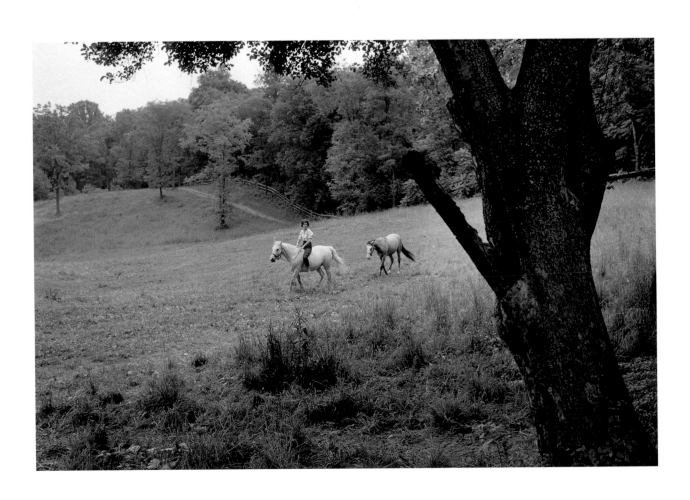

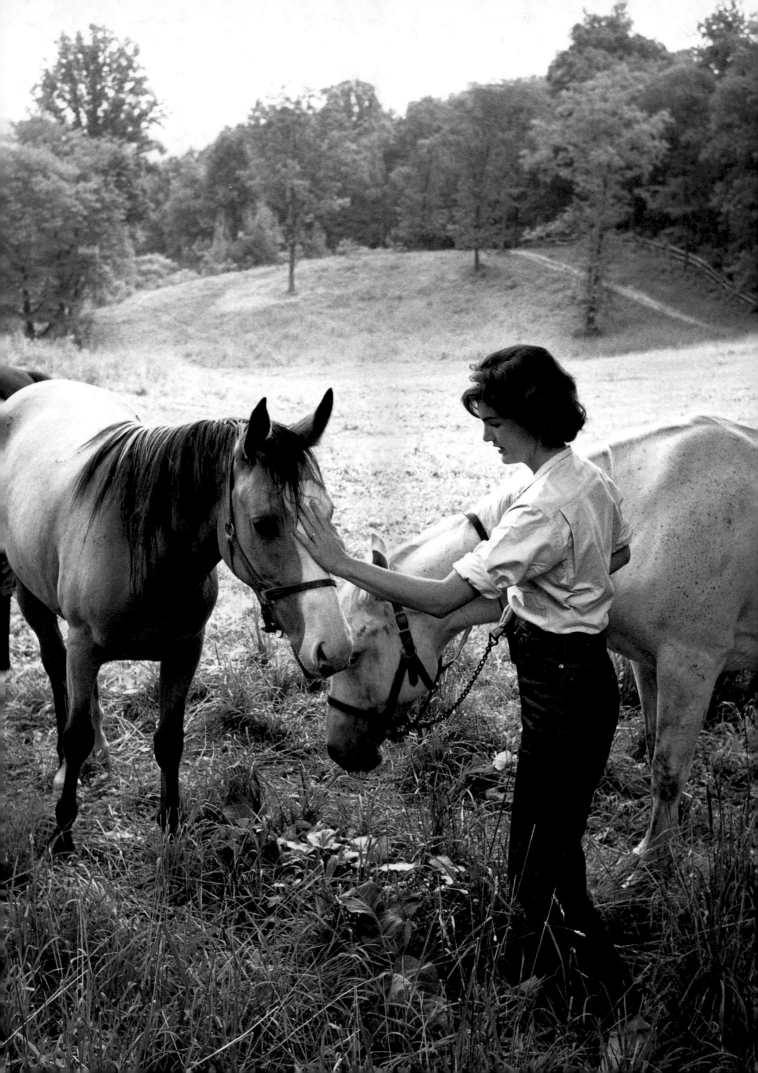

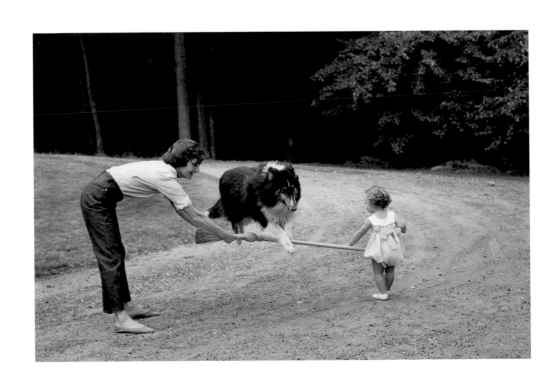

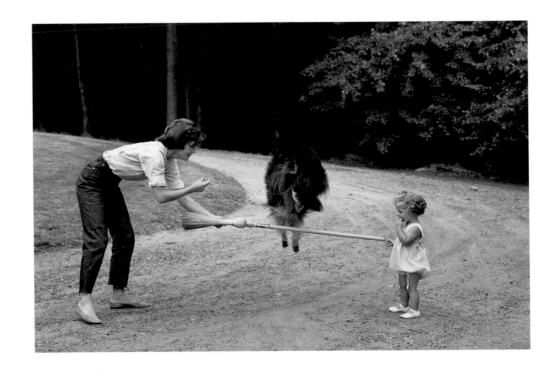

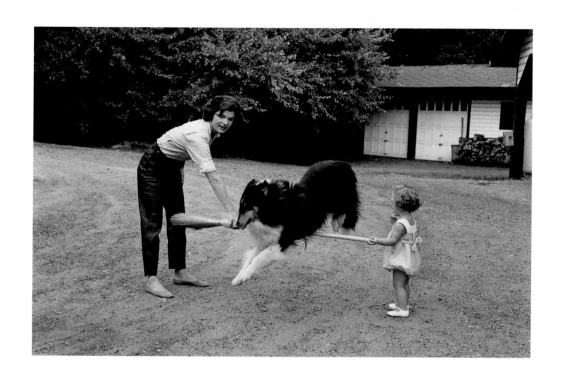

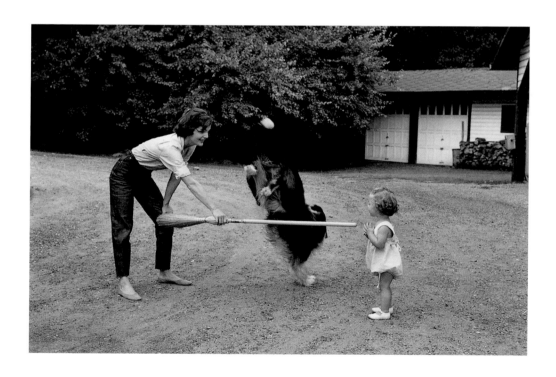

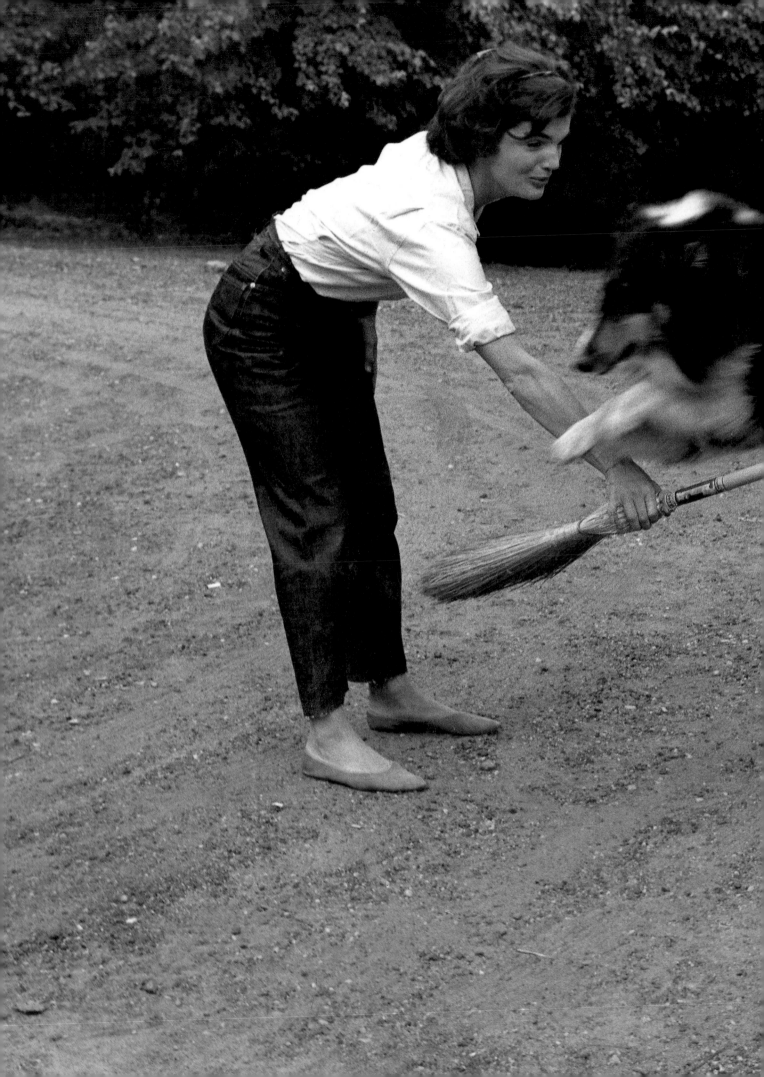

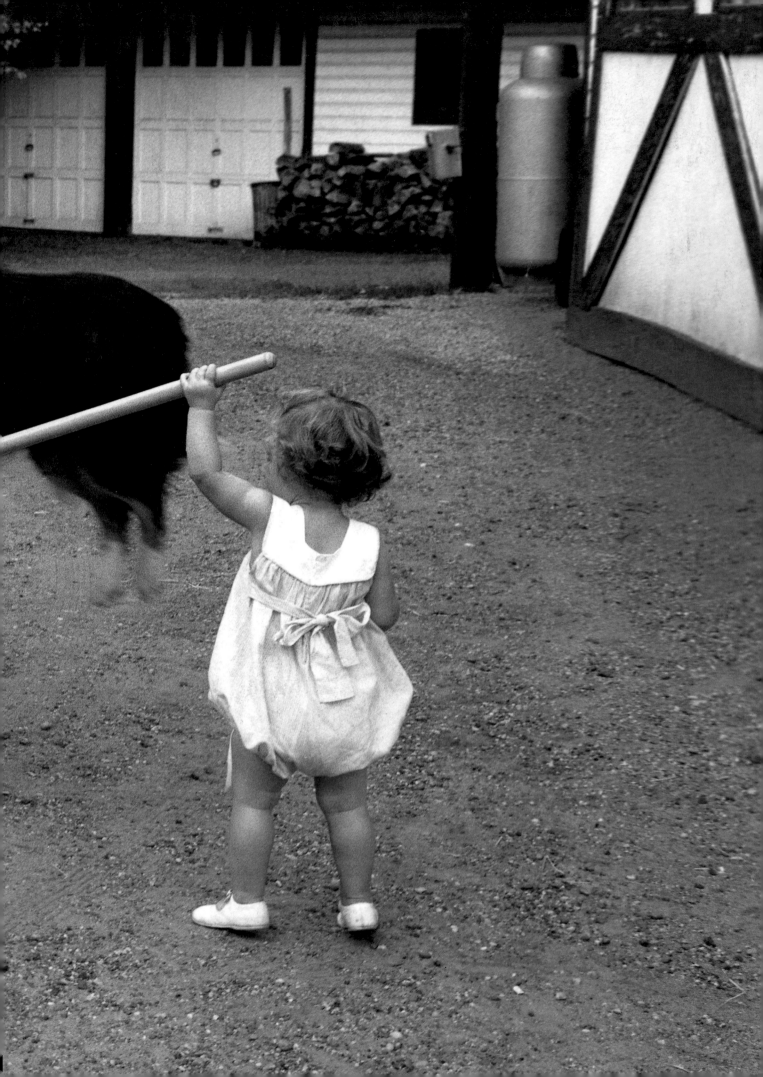

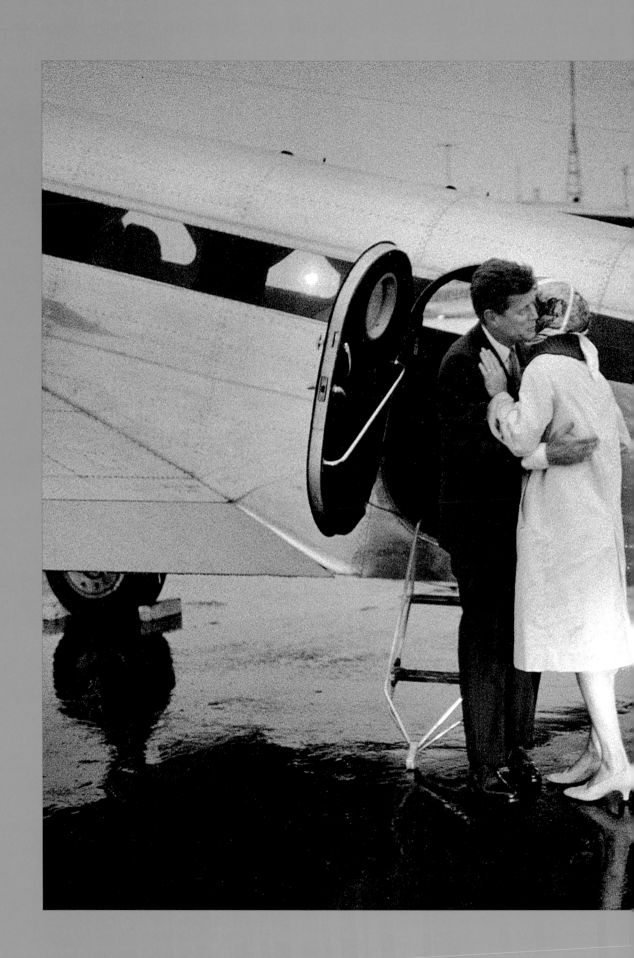

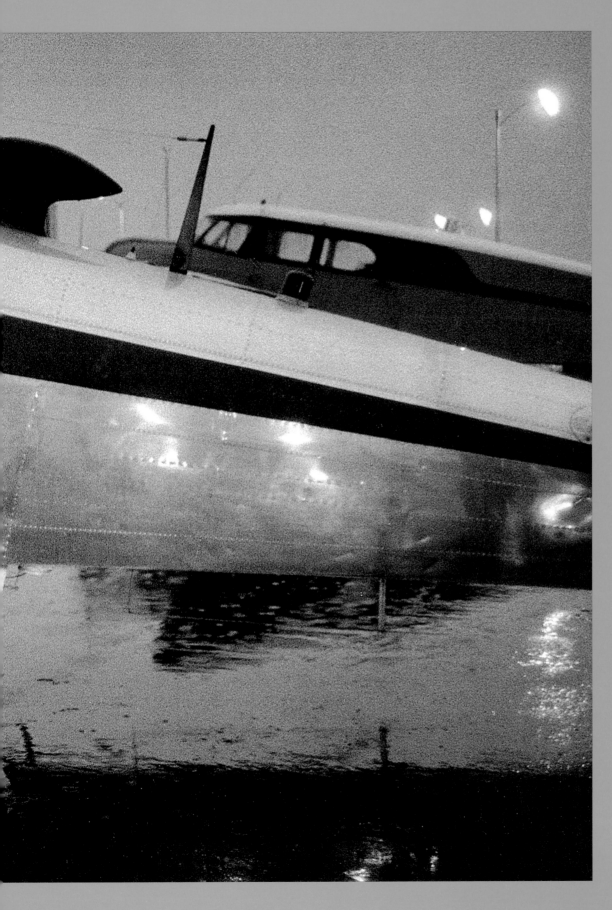

Hyannis and Hyannis Port

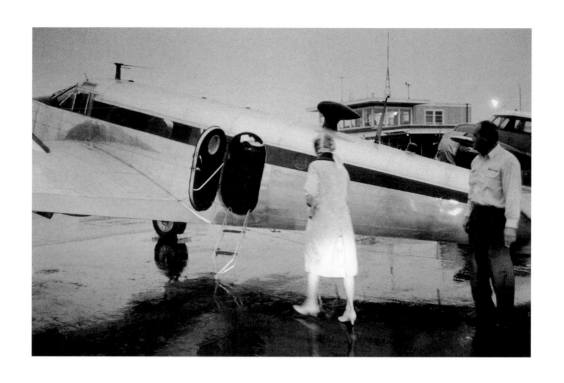

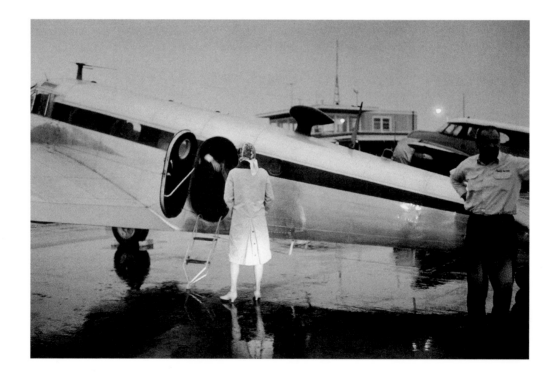

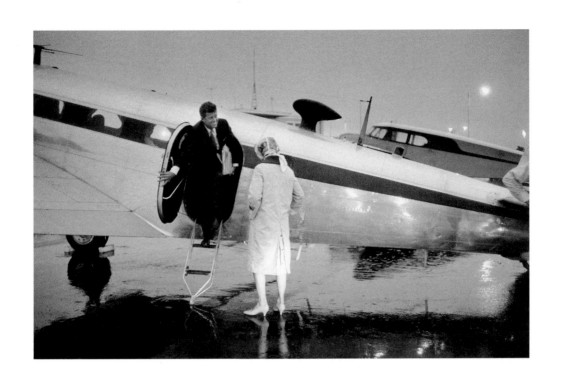

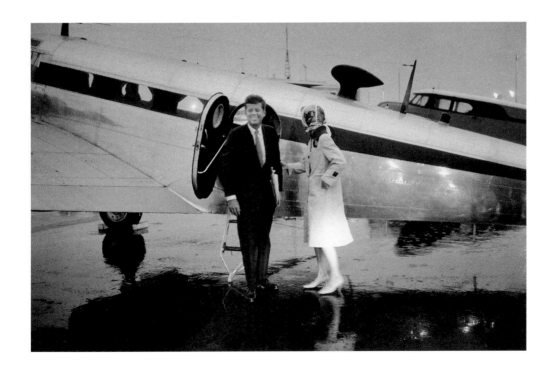

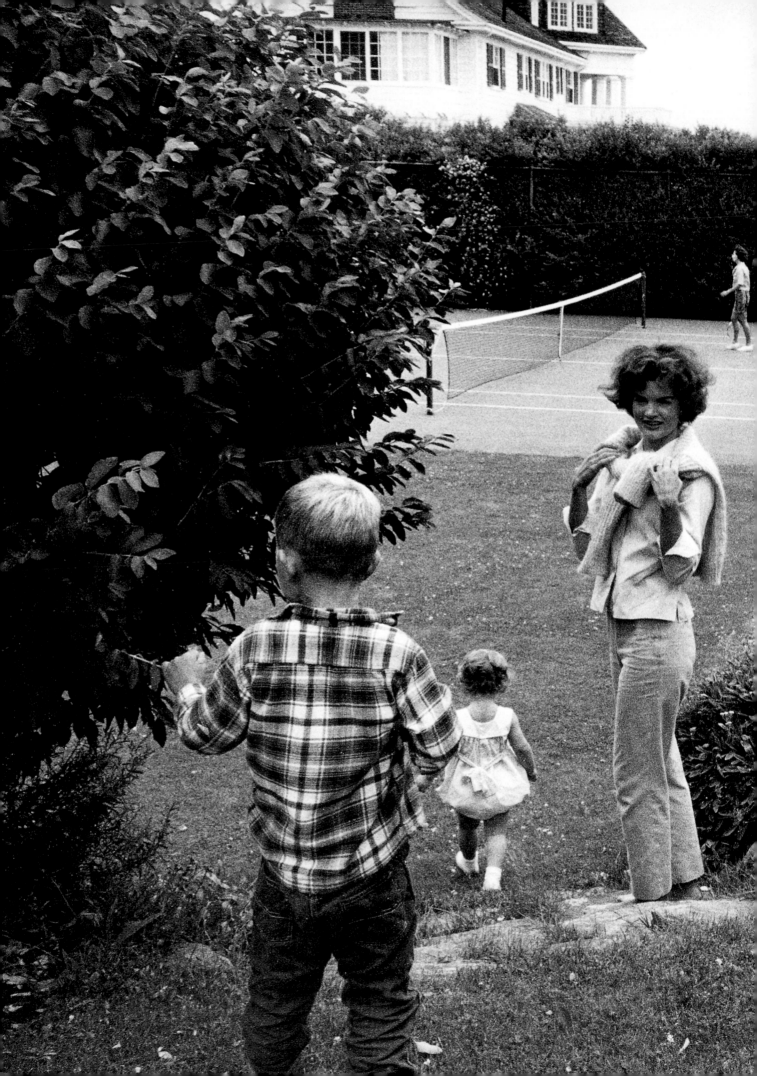

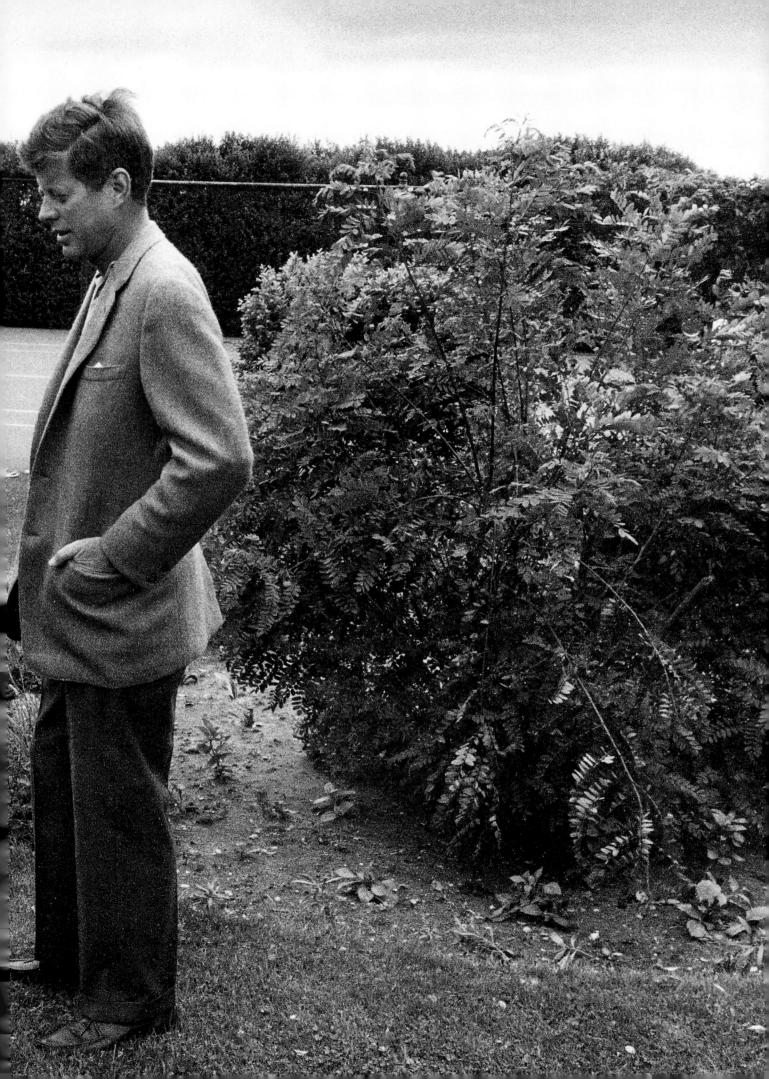

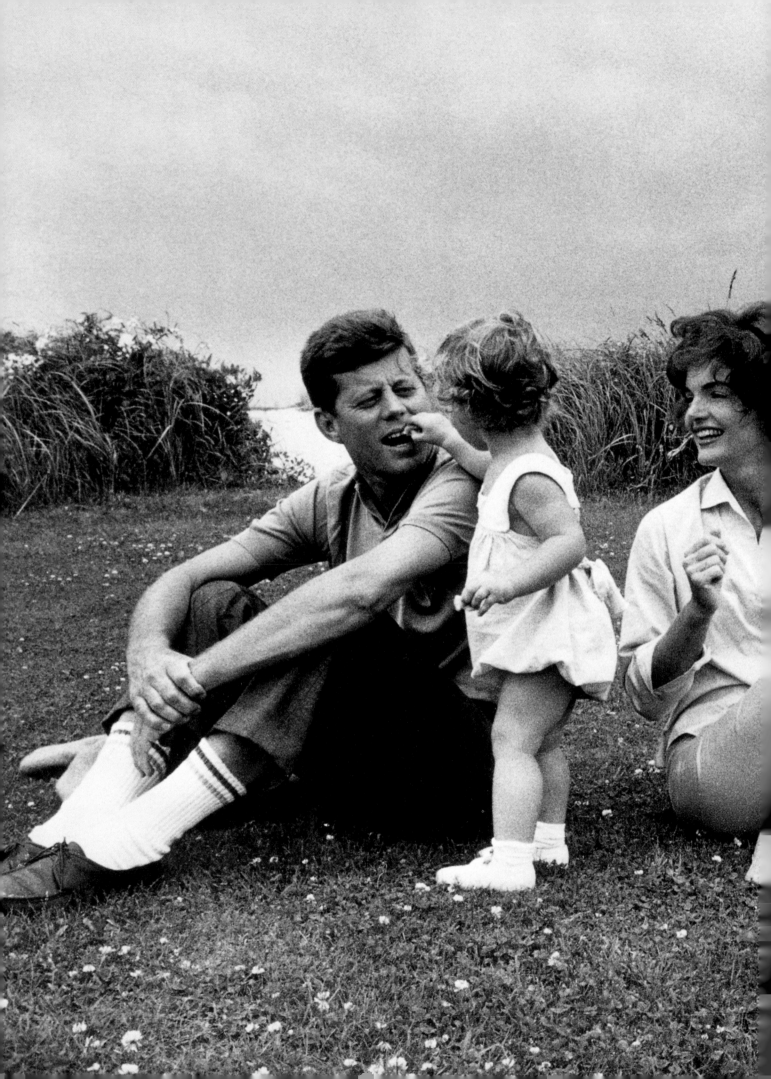

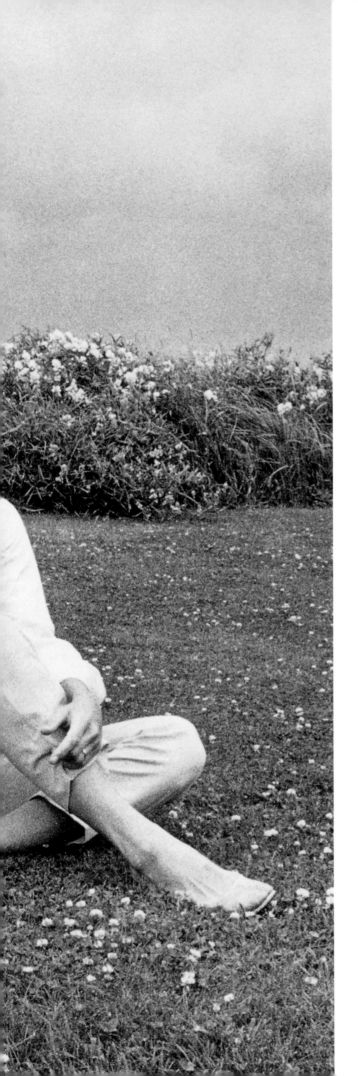

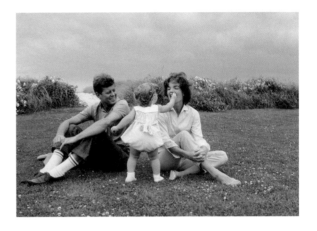

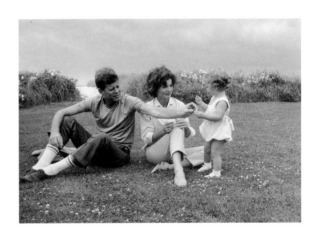

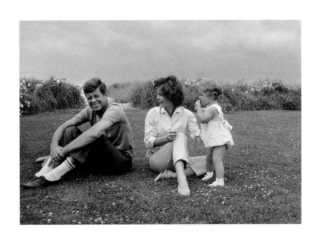

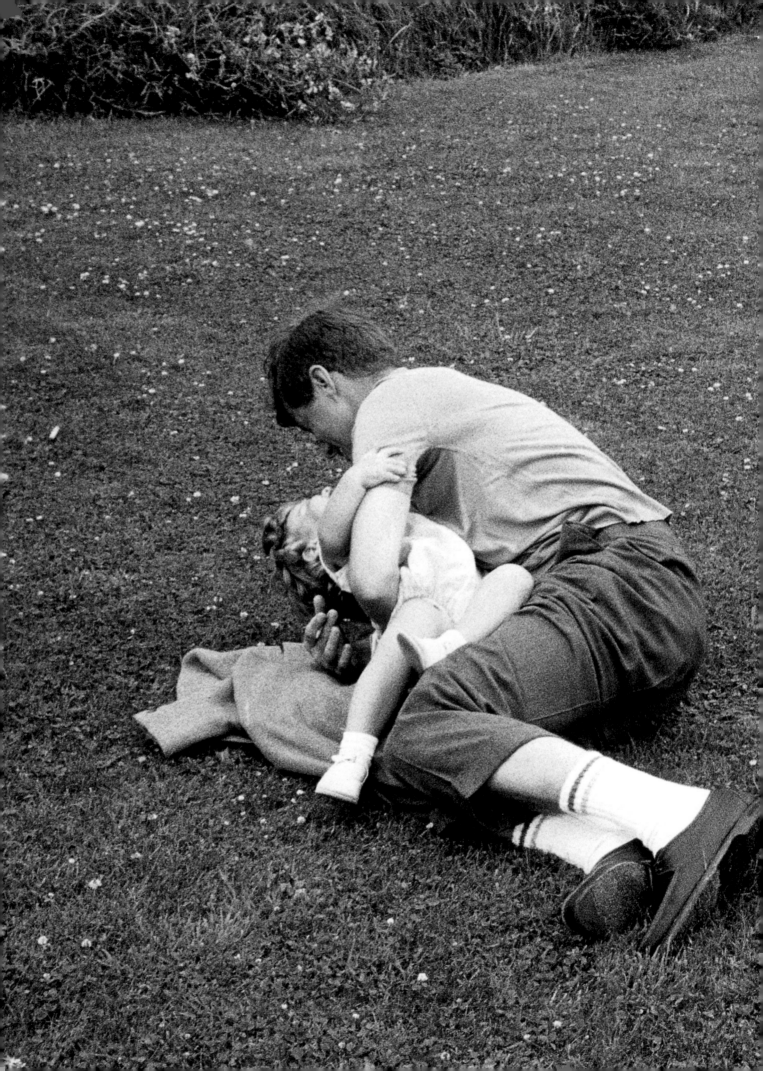

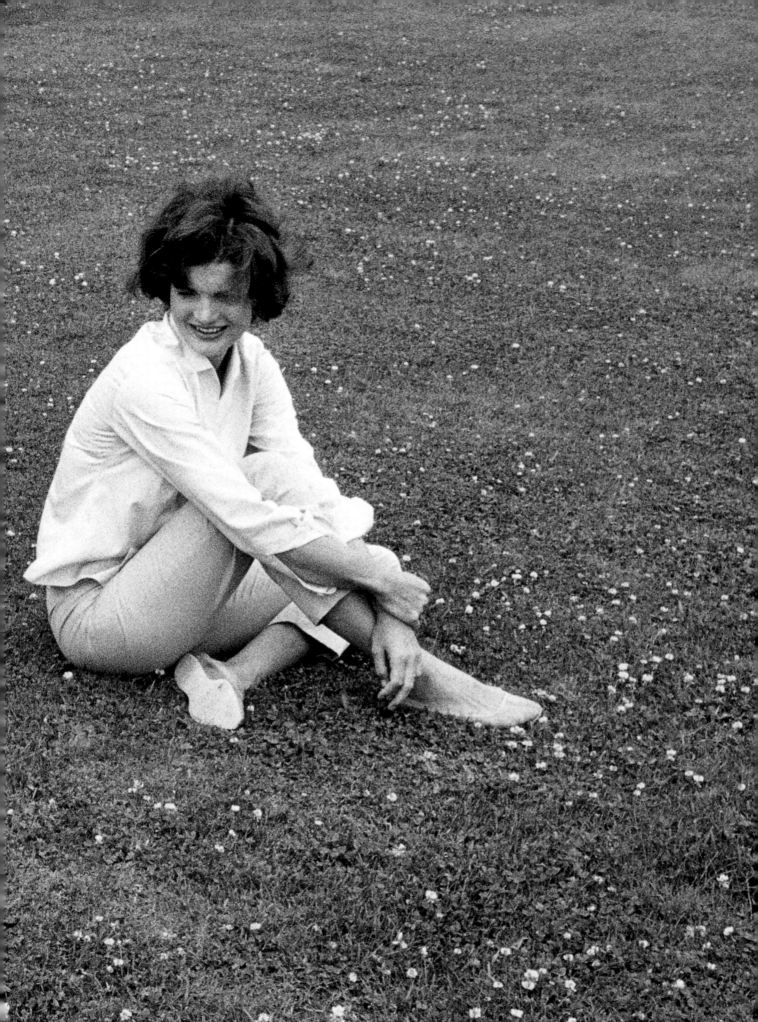

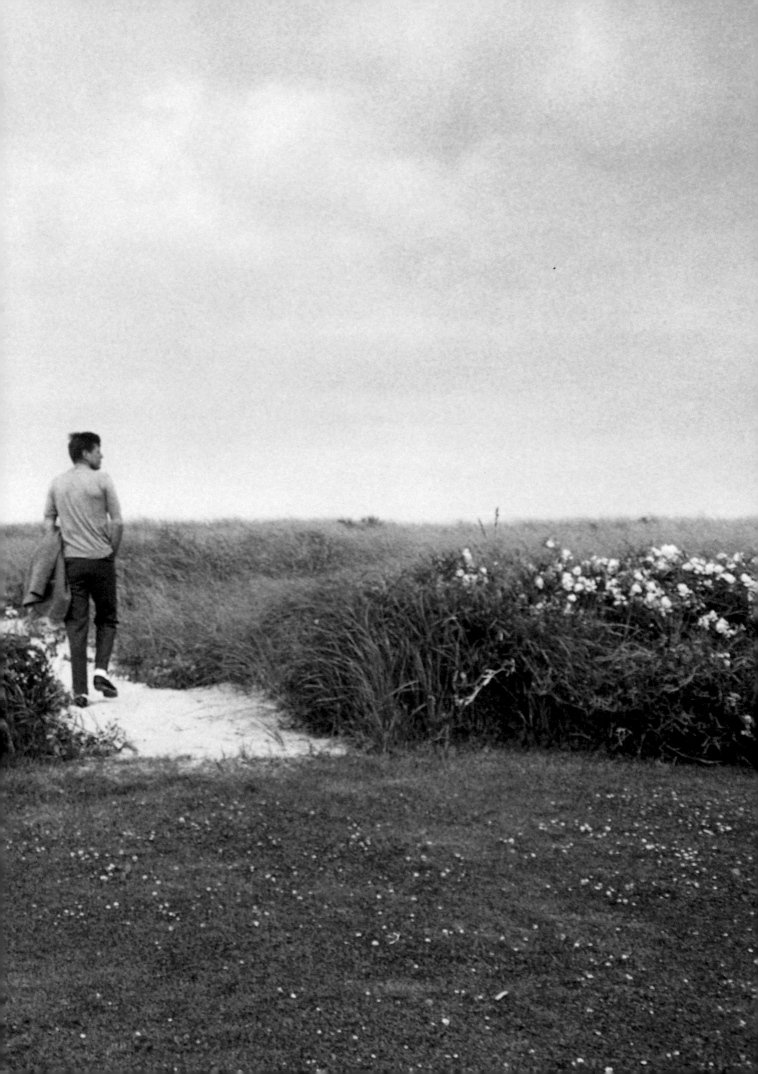

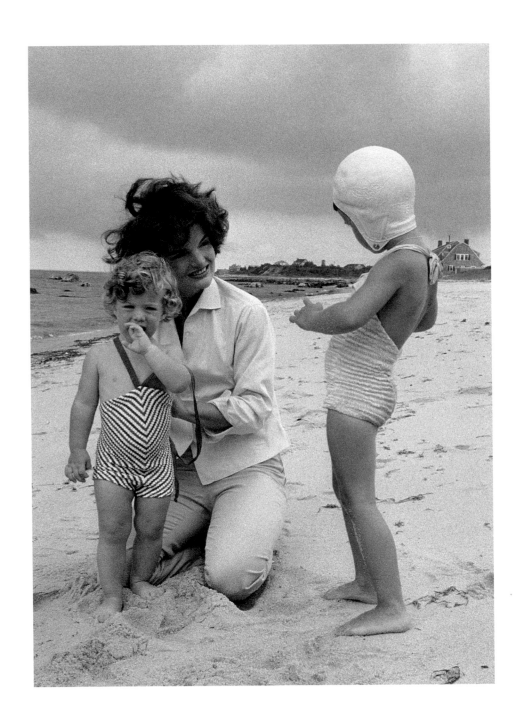

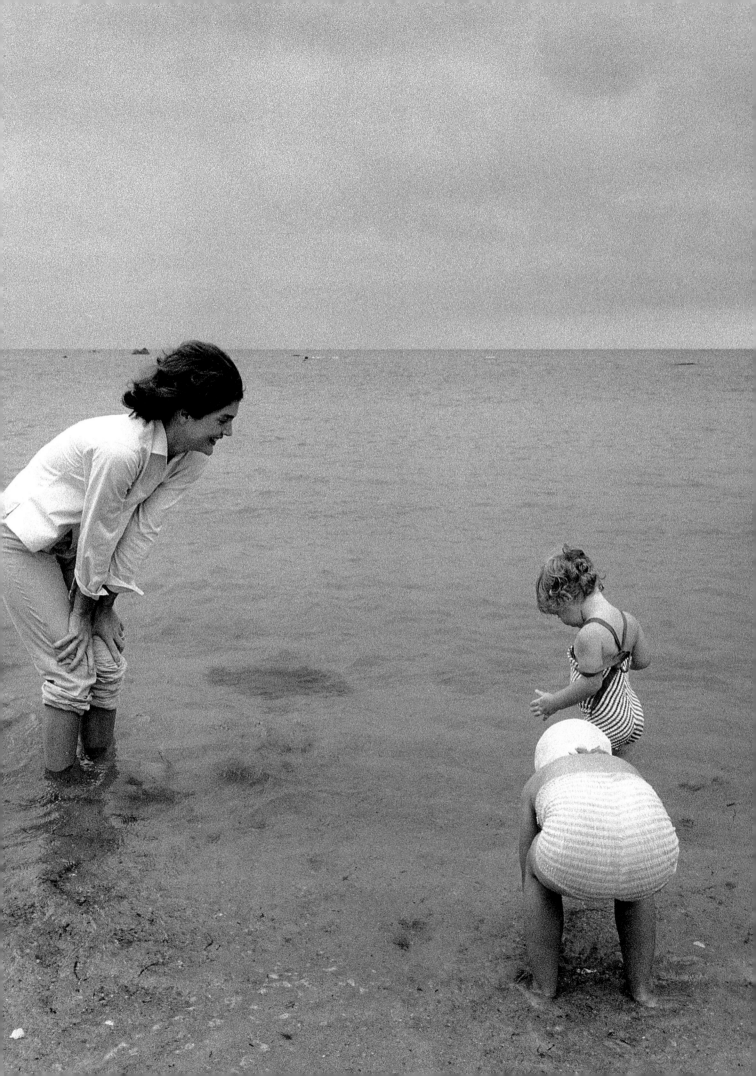

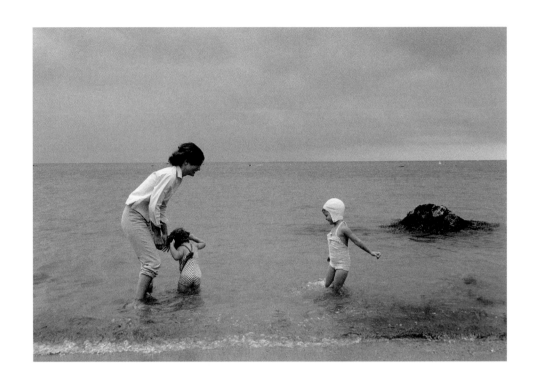

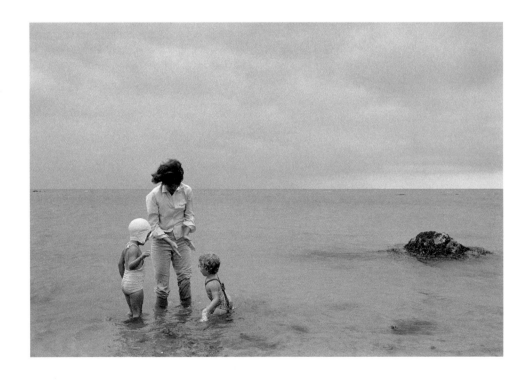

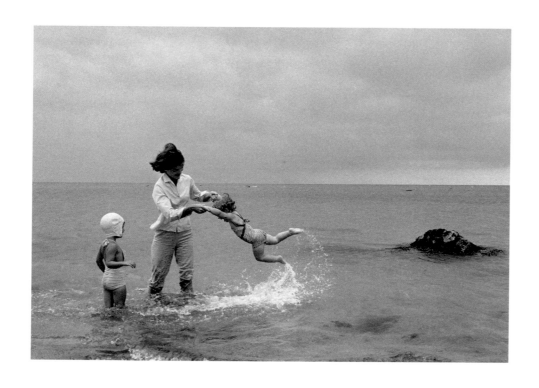

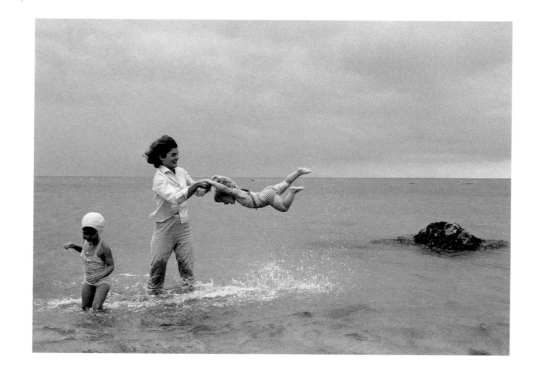

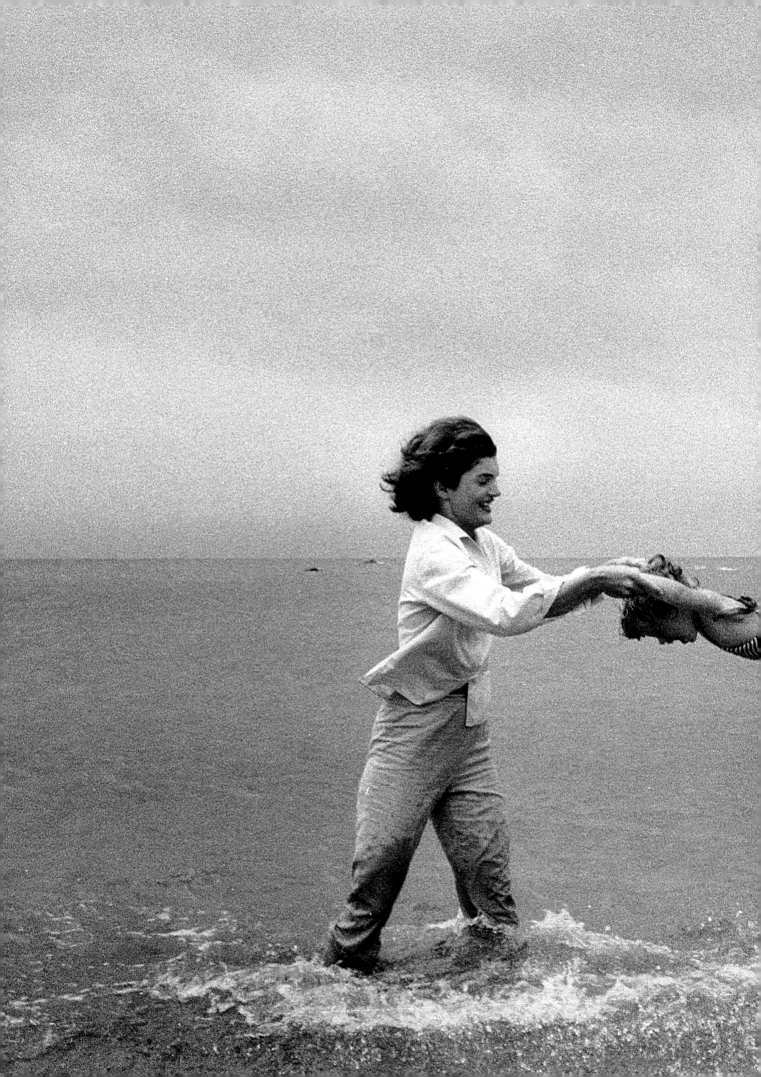

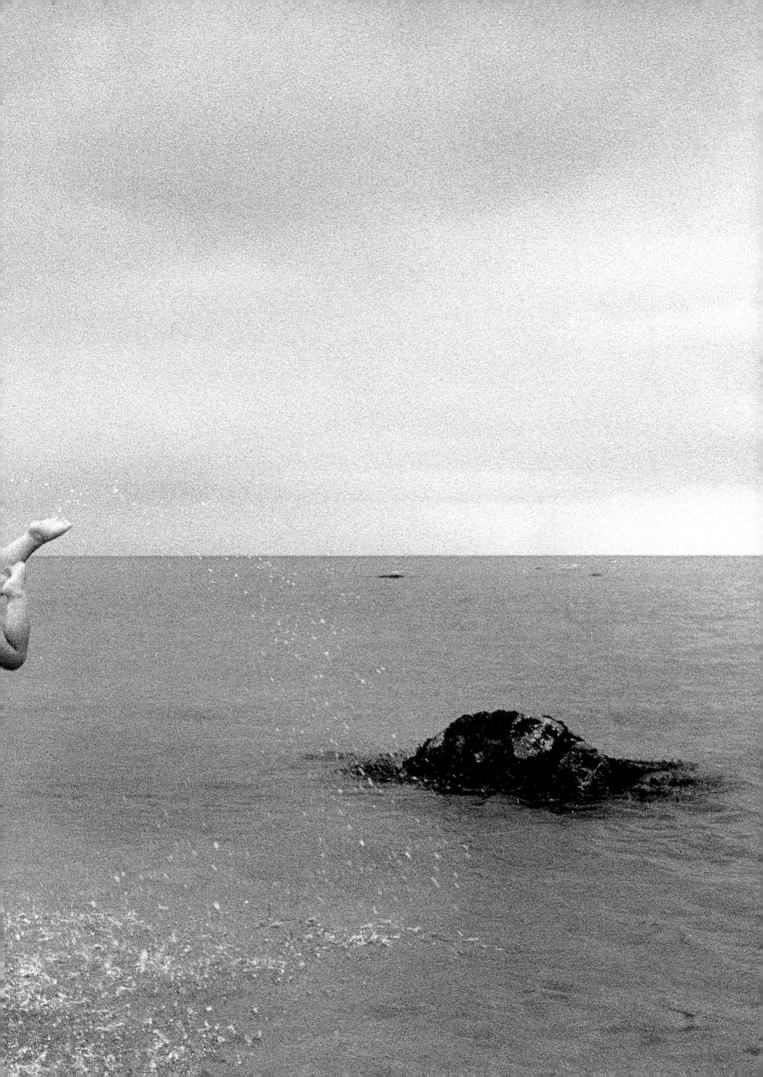

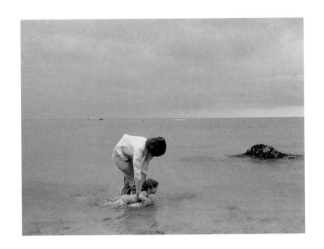

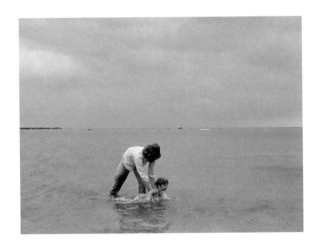

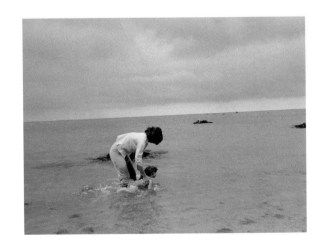

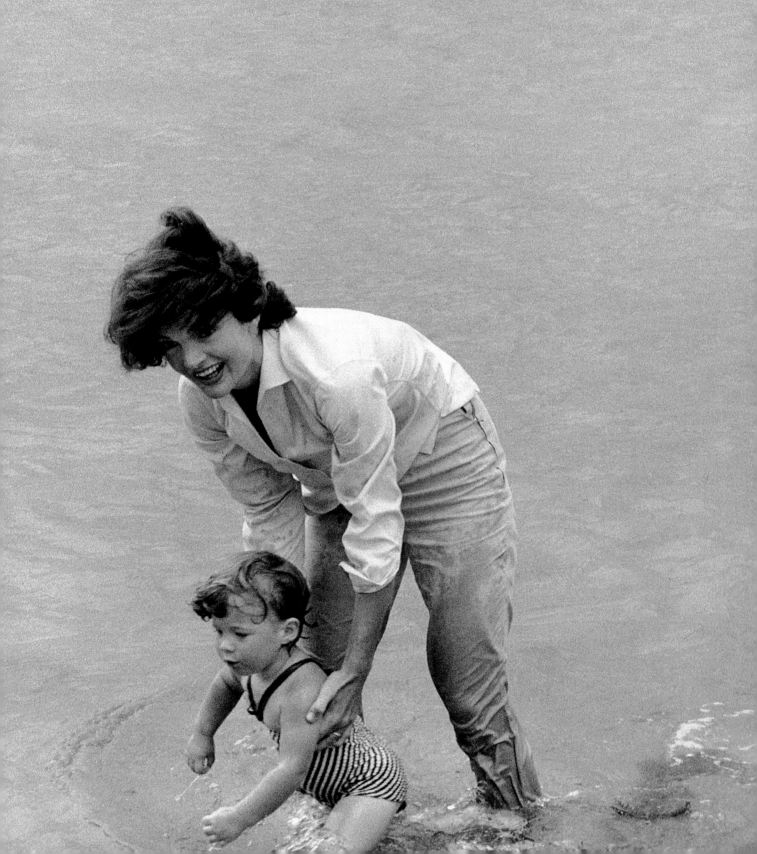

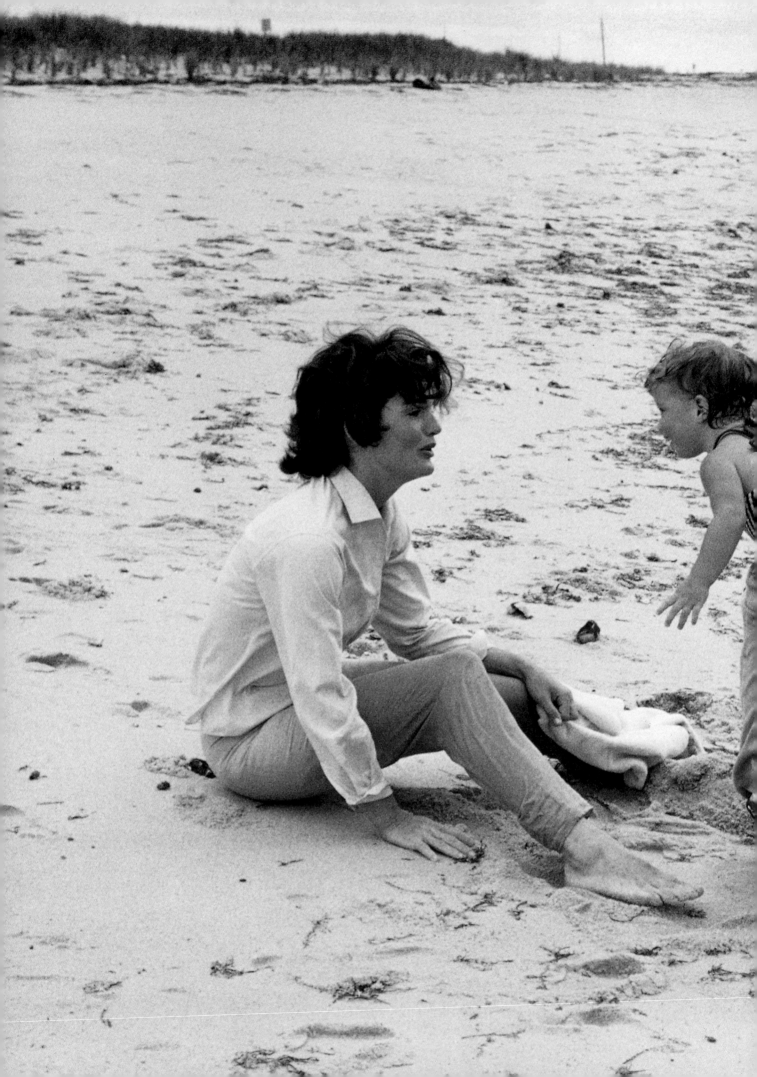

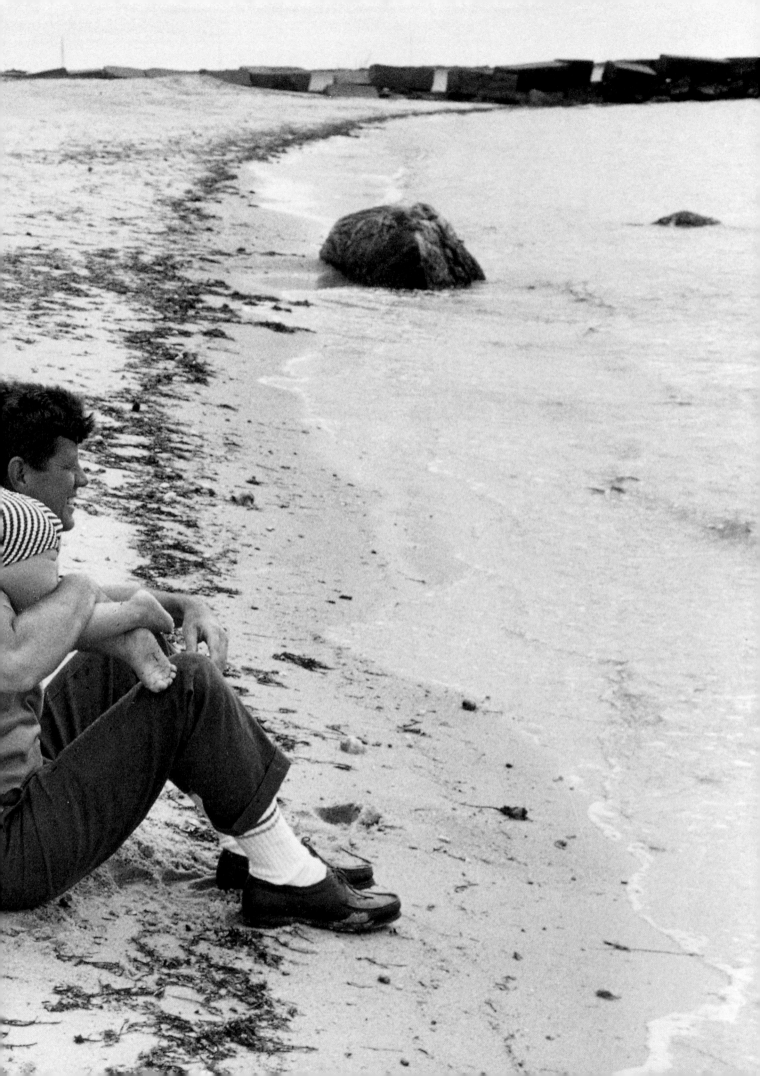

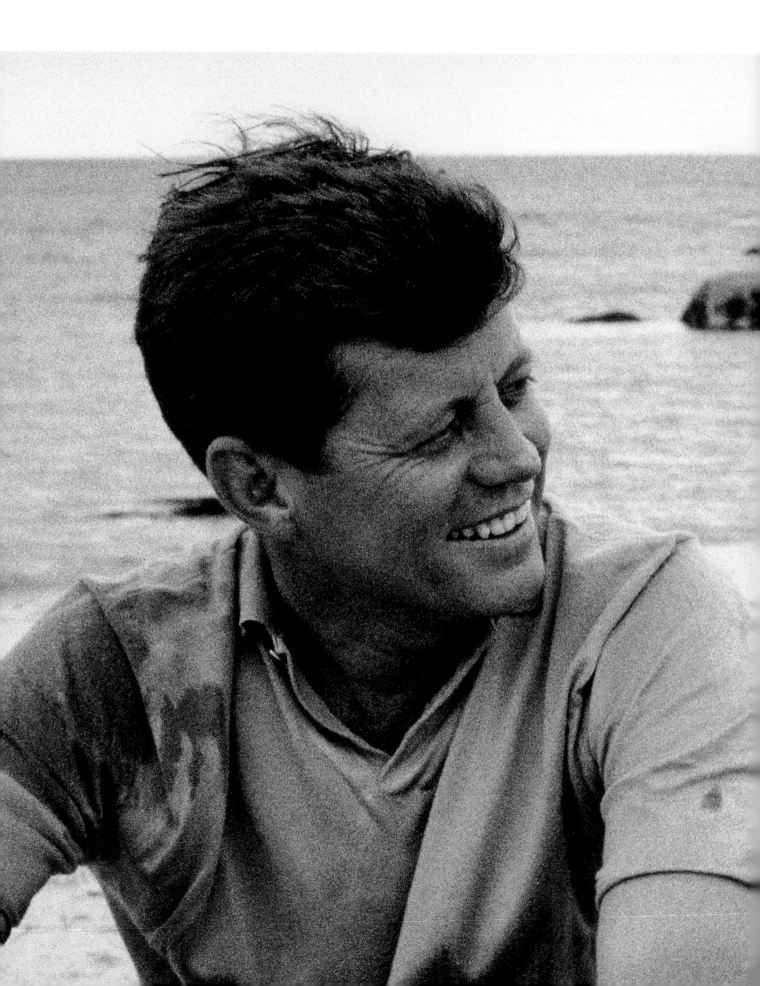

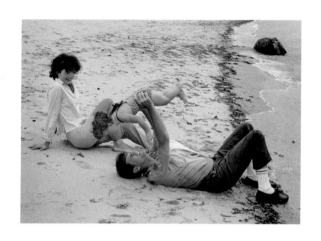 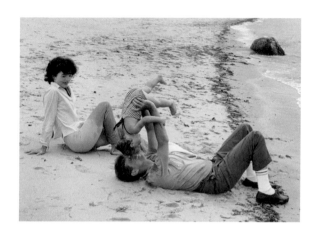

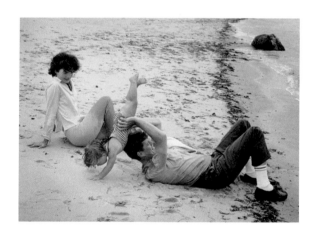 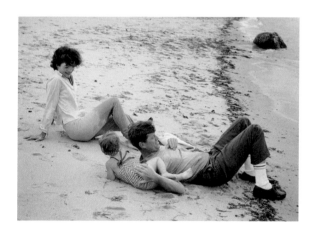

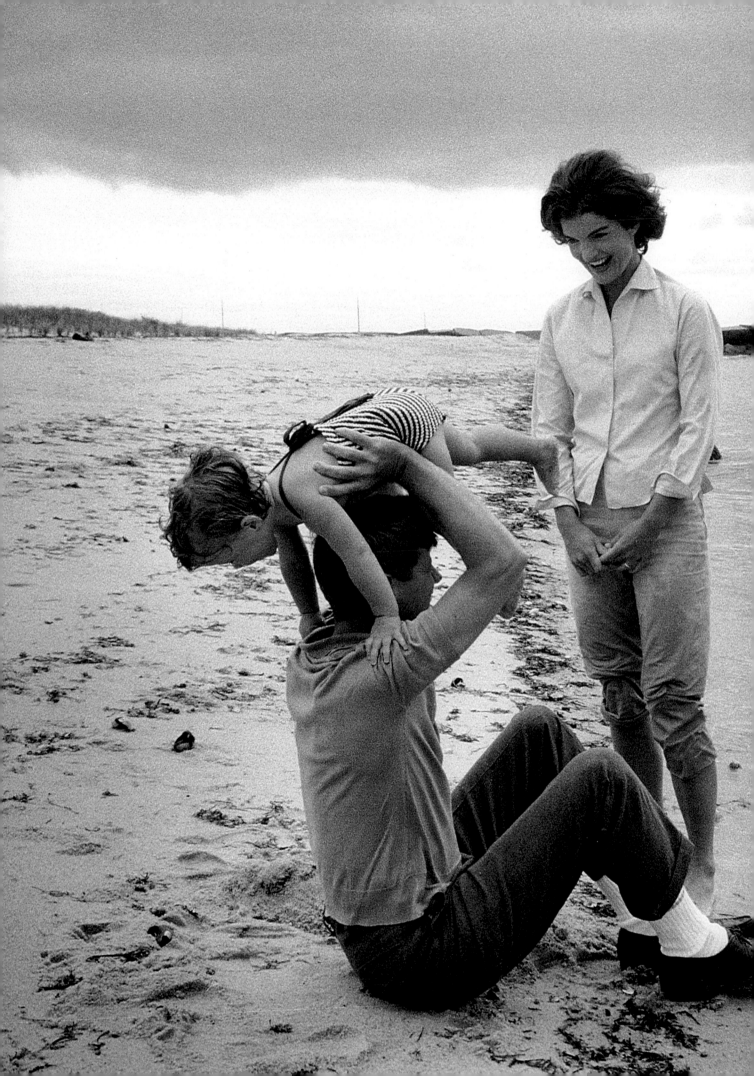

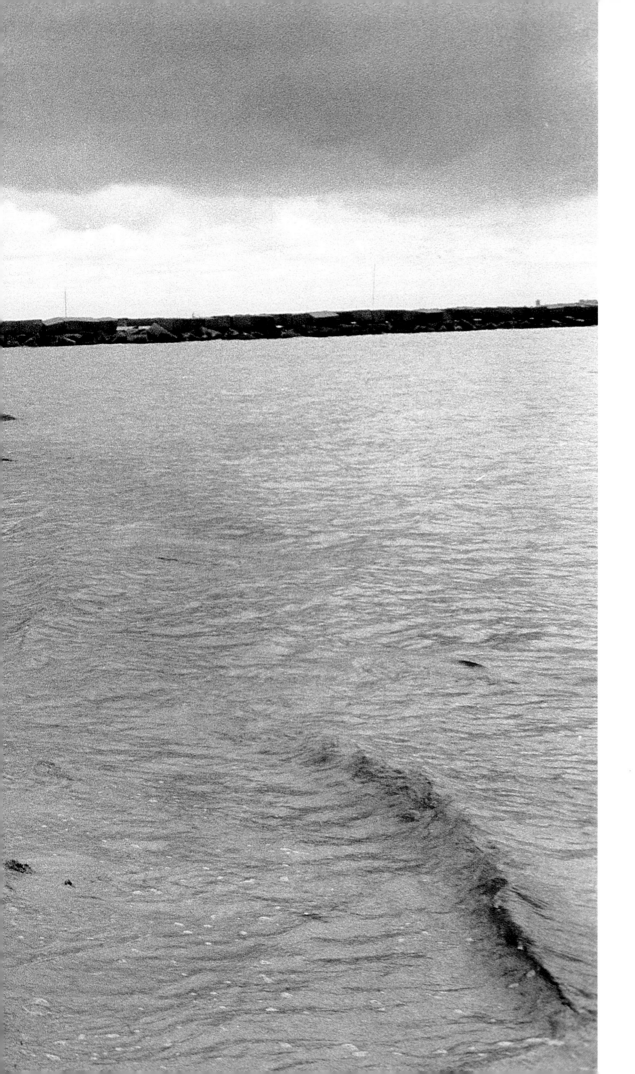

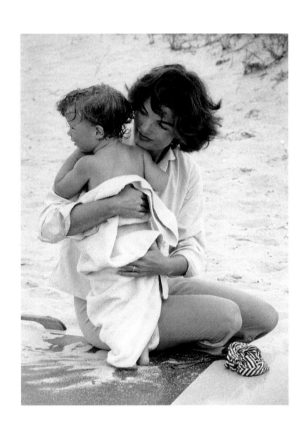

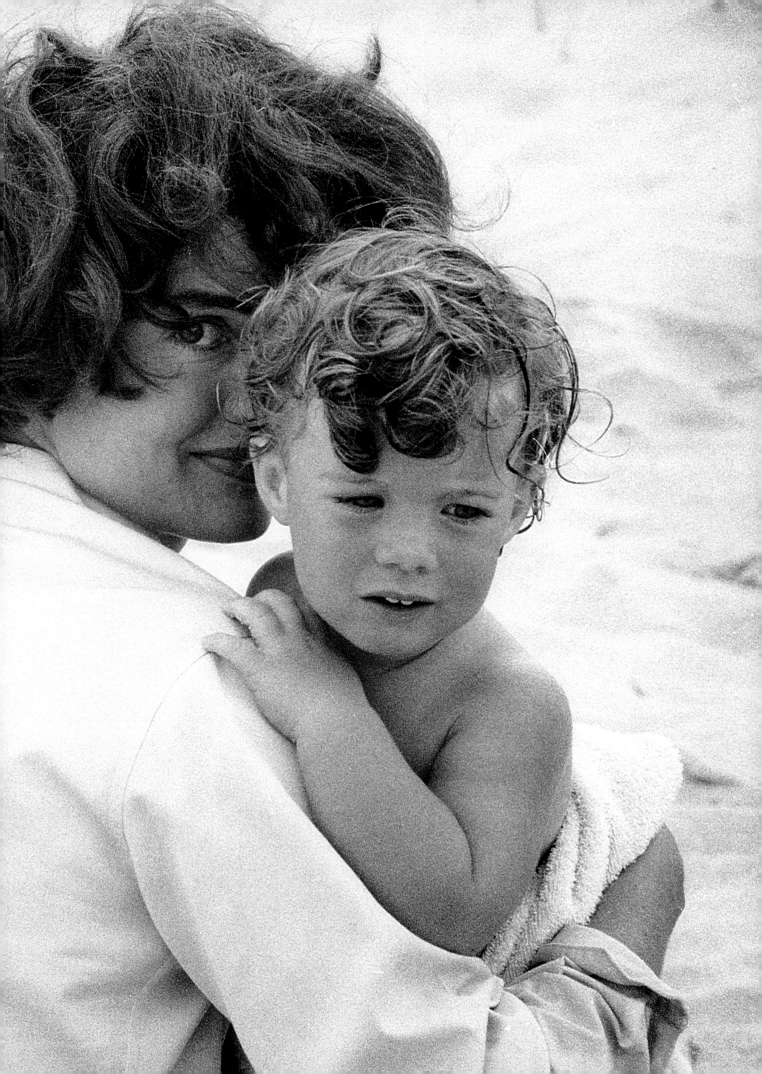

Washington, D.C.

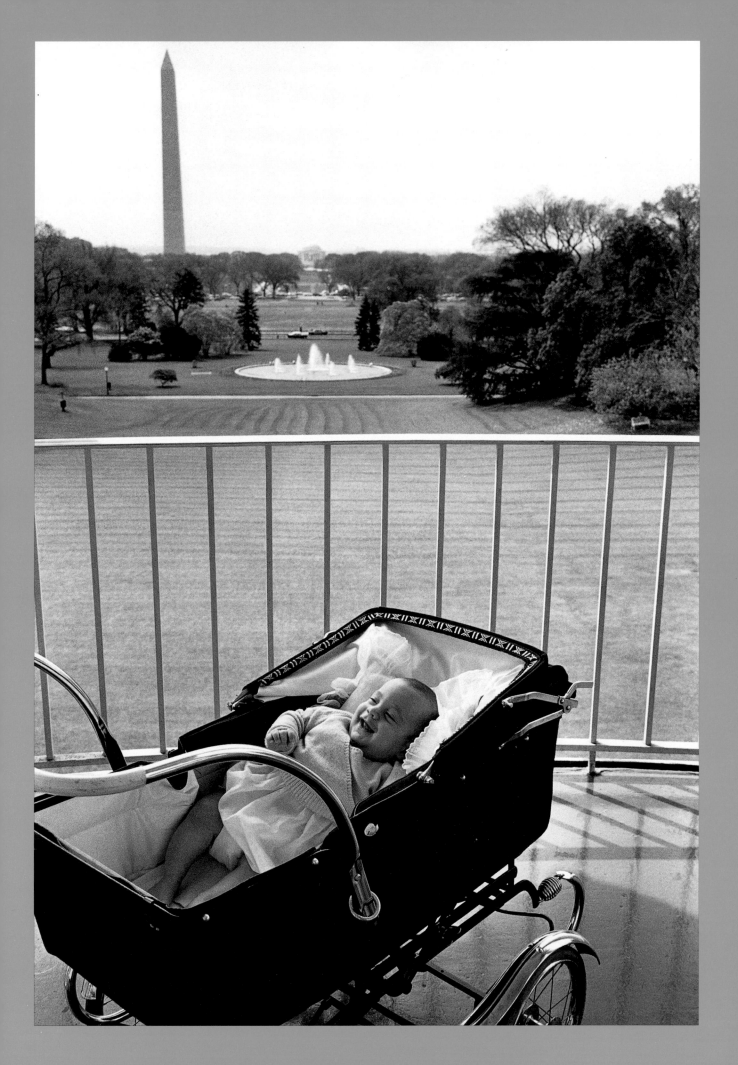

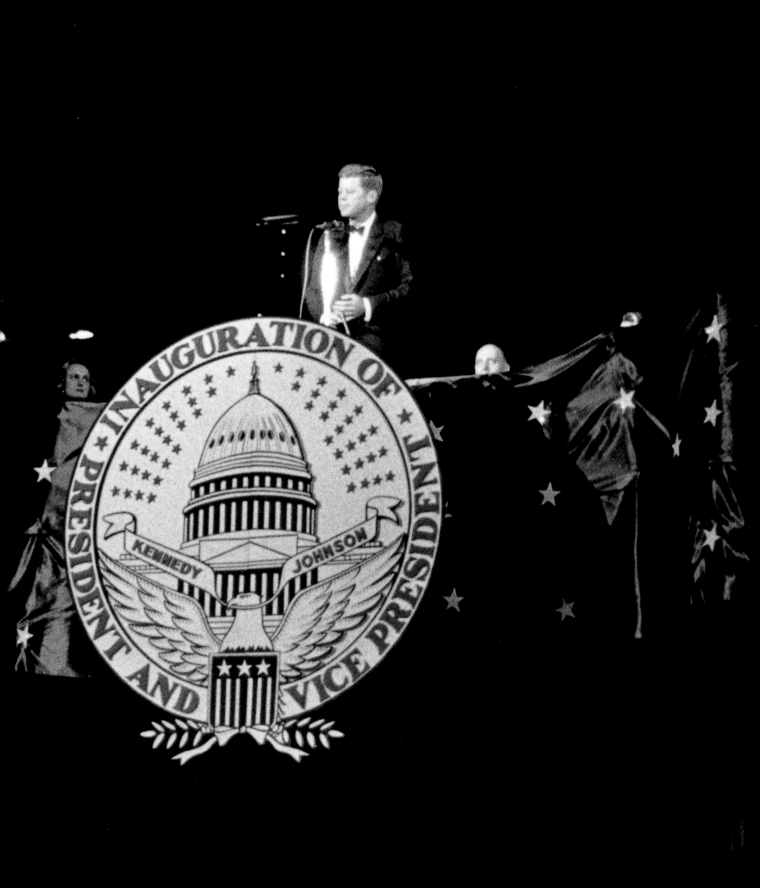

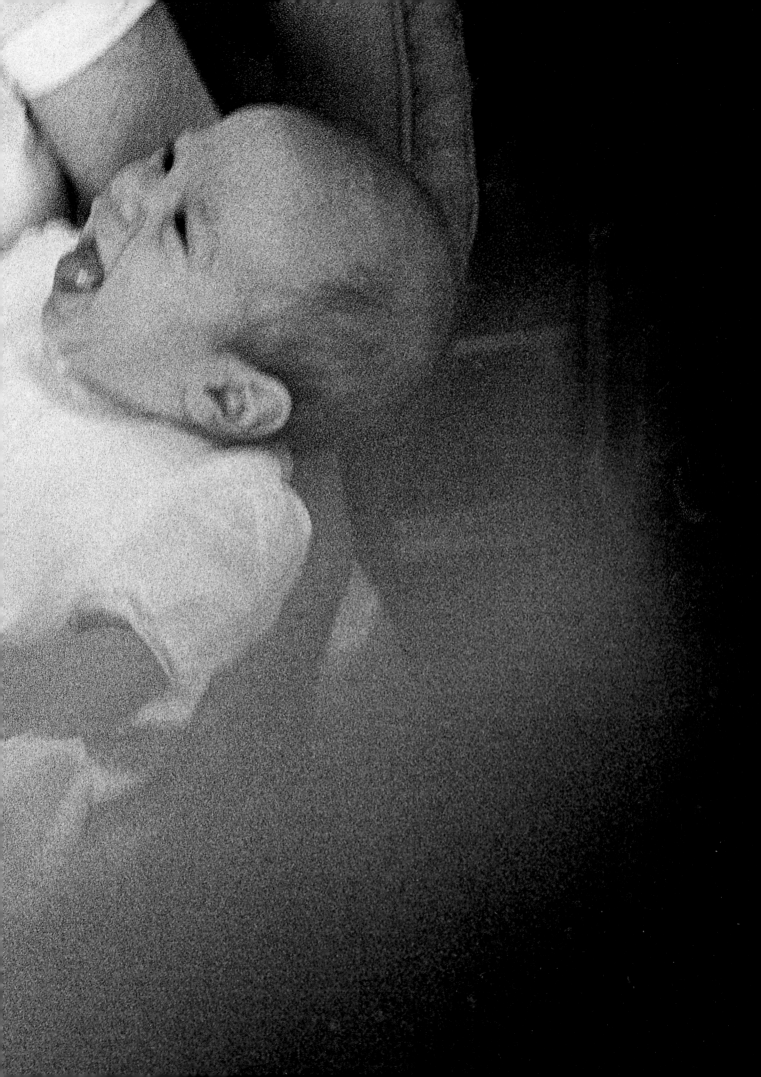

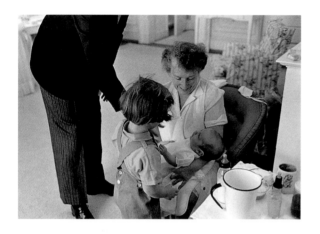

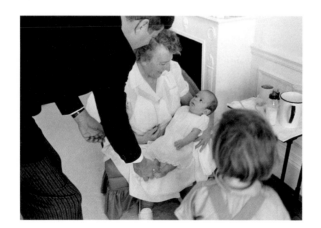

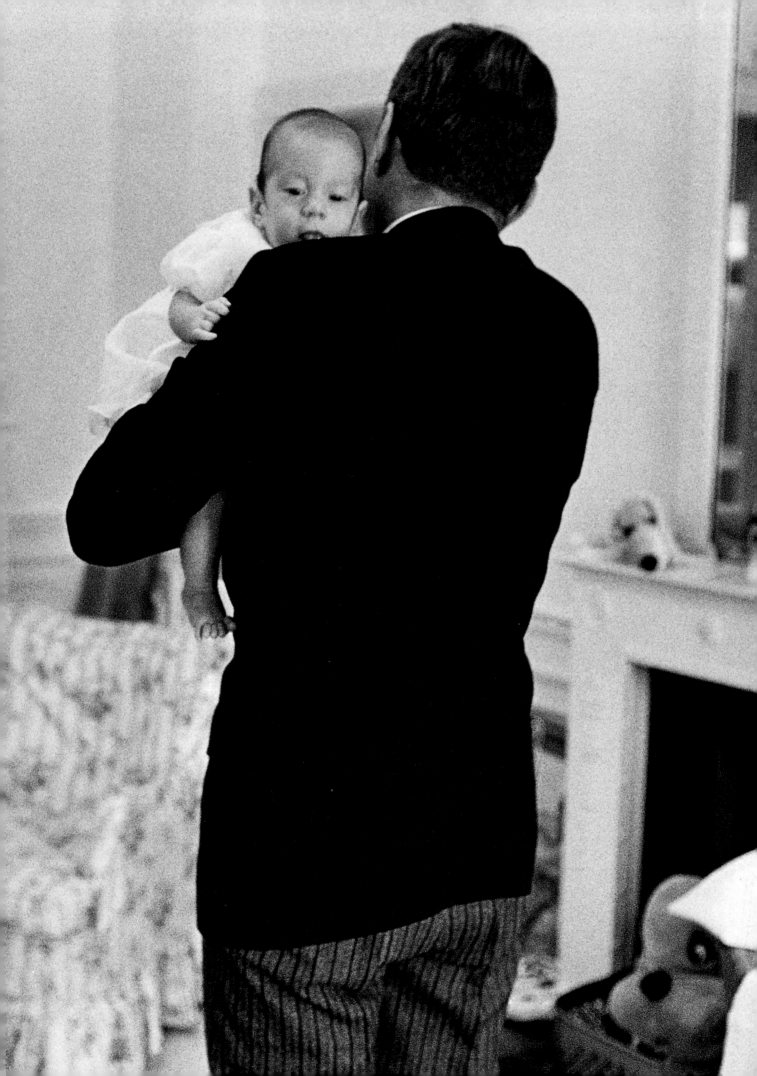

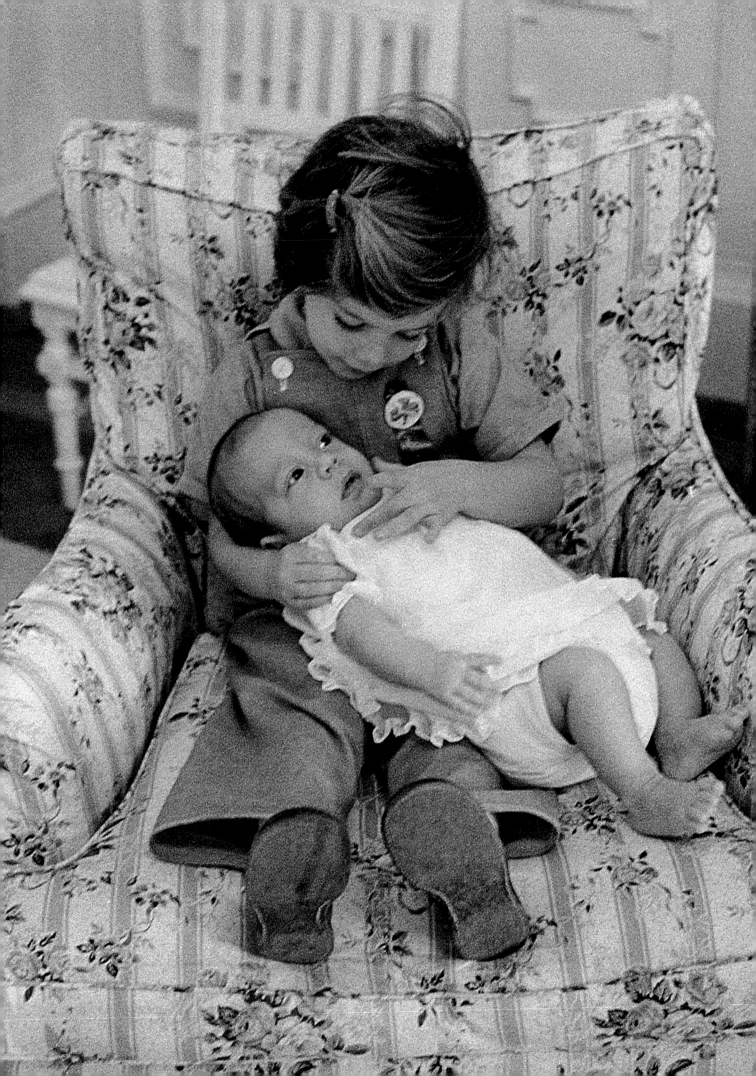

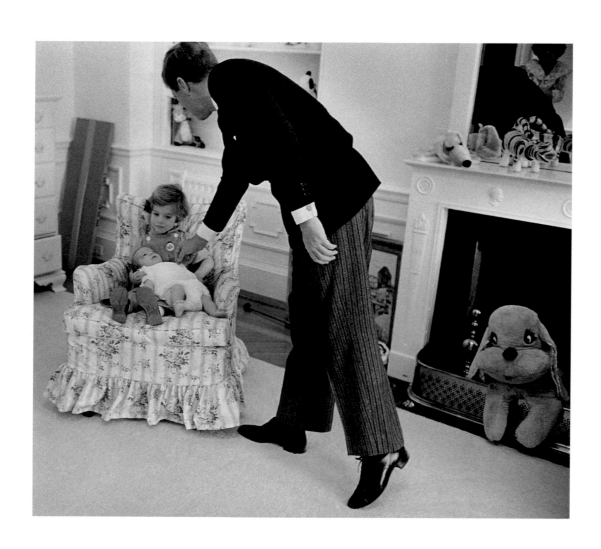

Hyannis Port

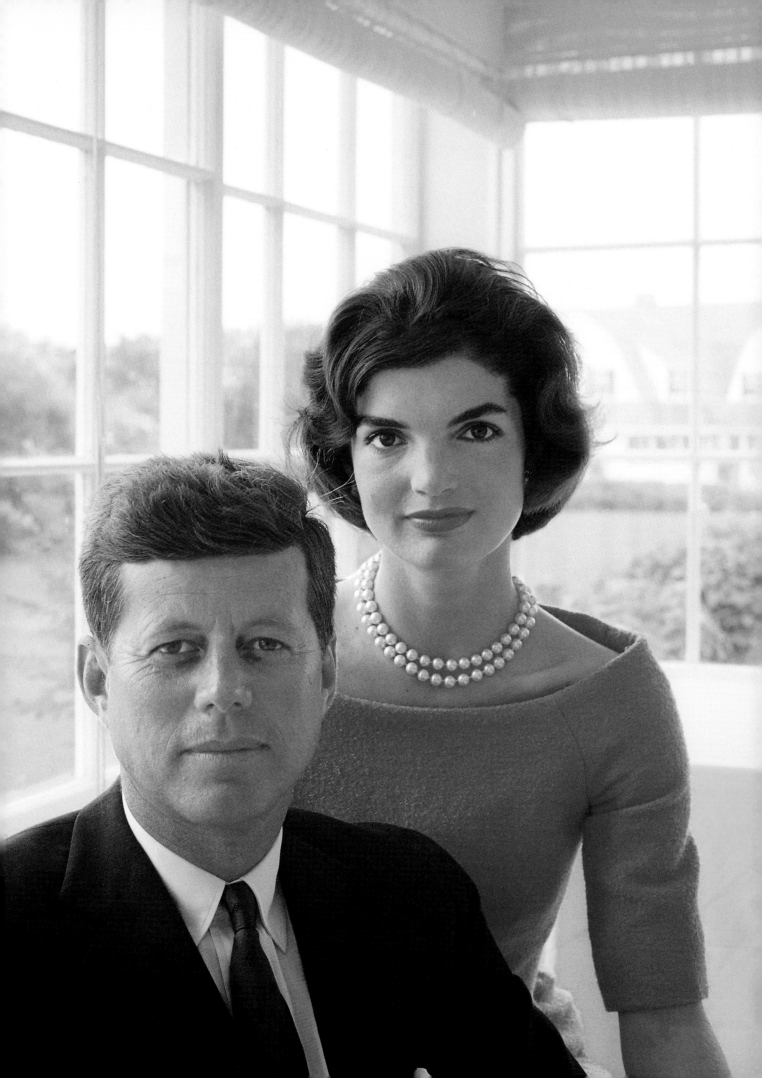

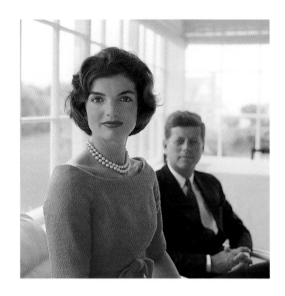
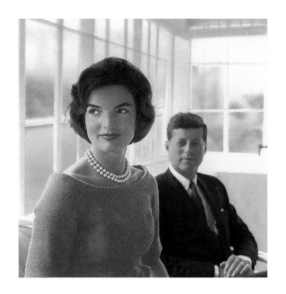
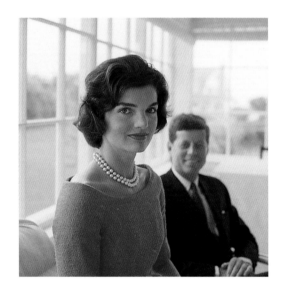
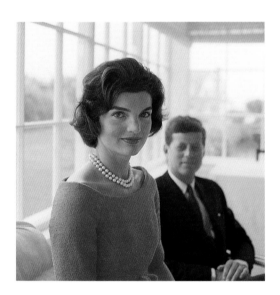

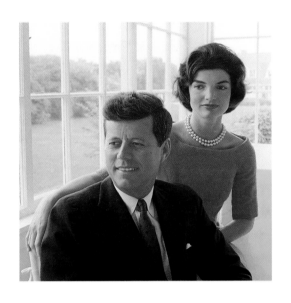
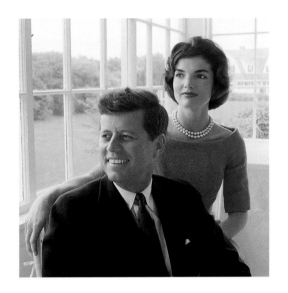
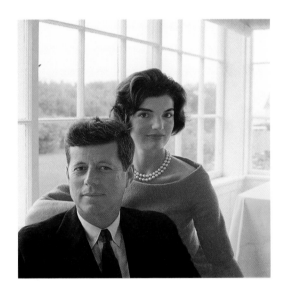
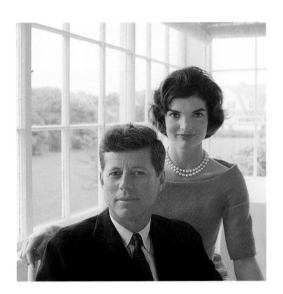

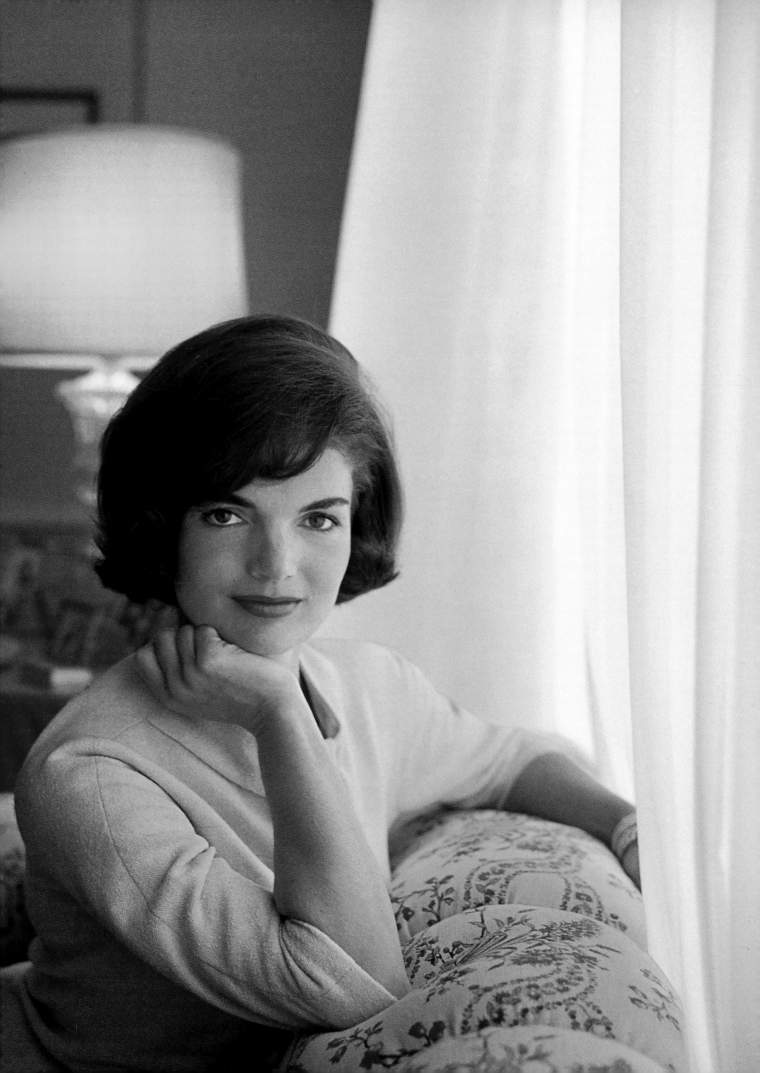

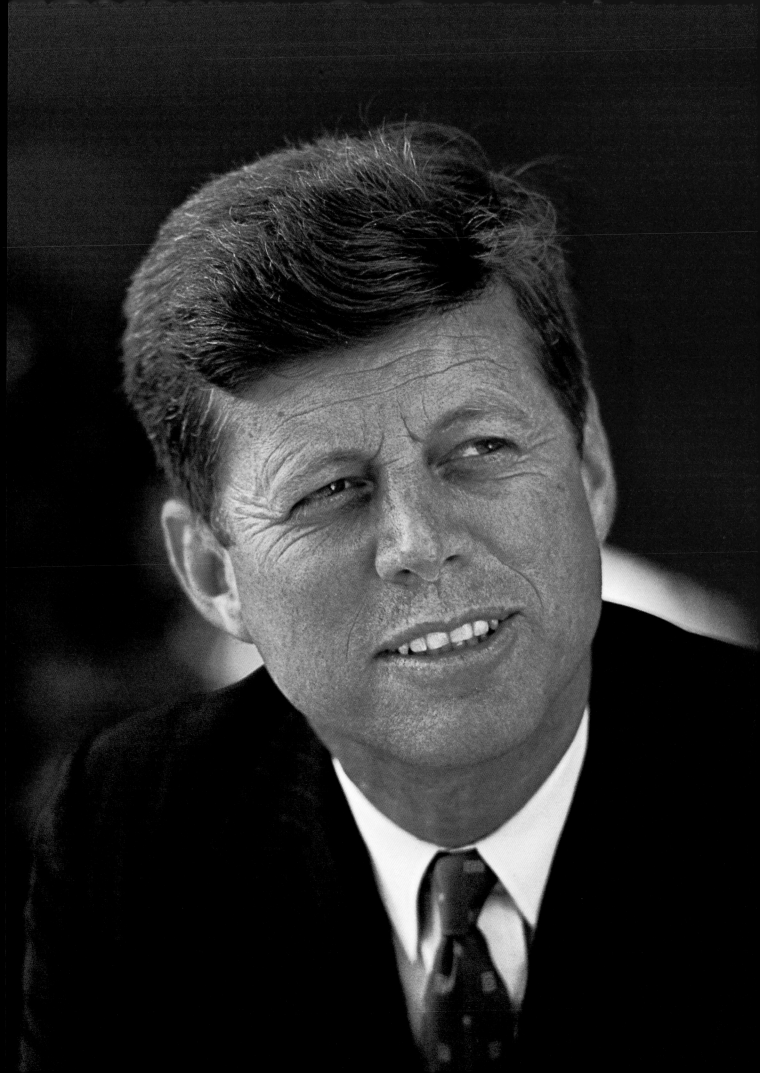

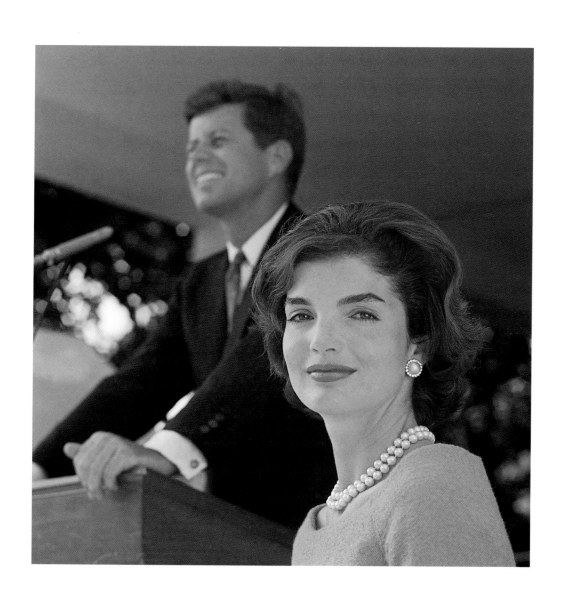

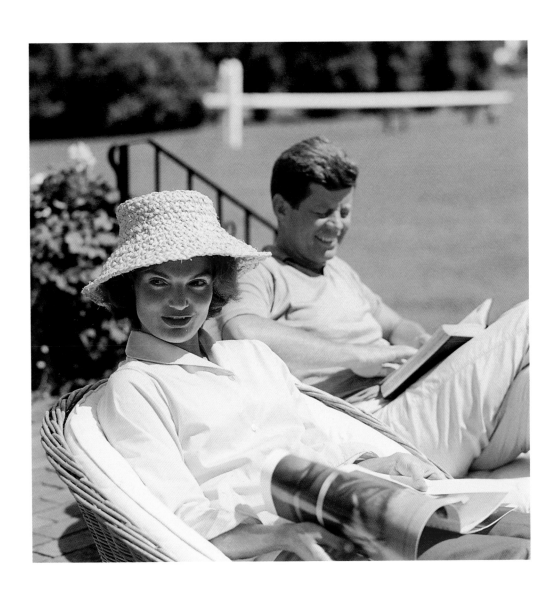

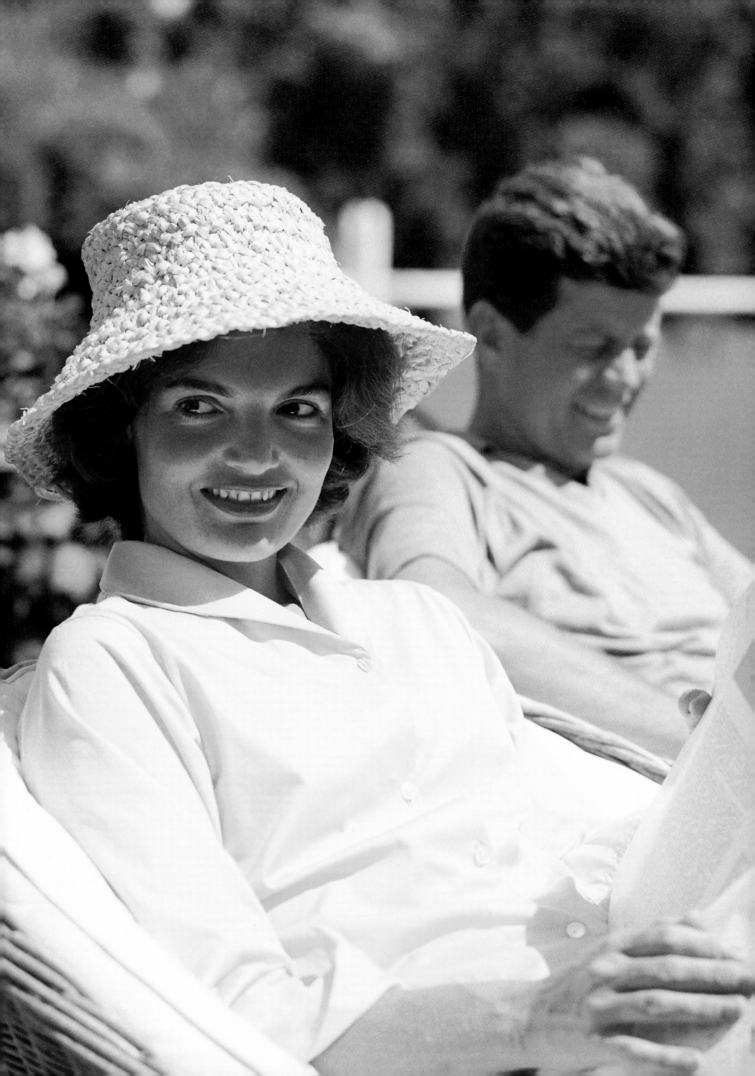

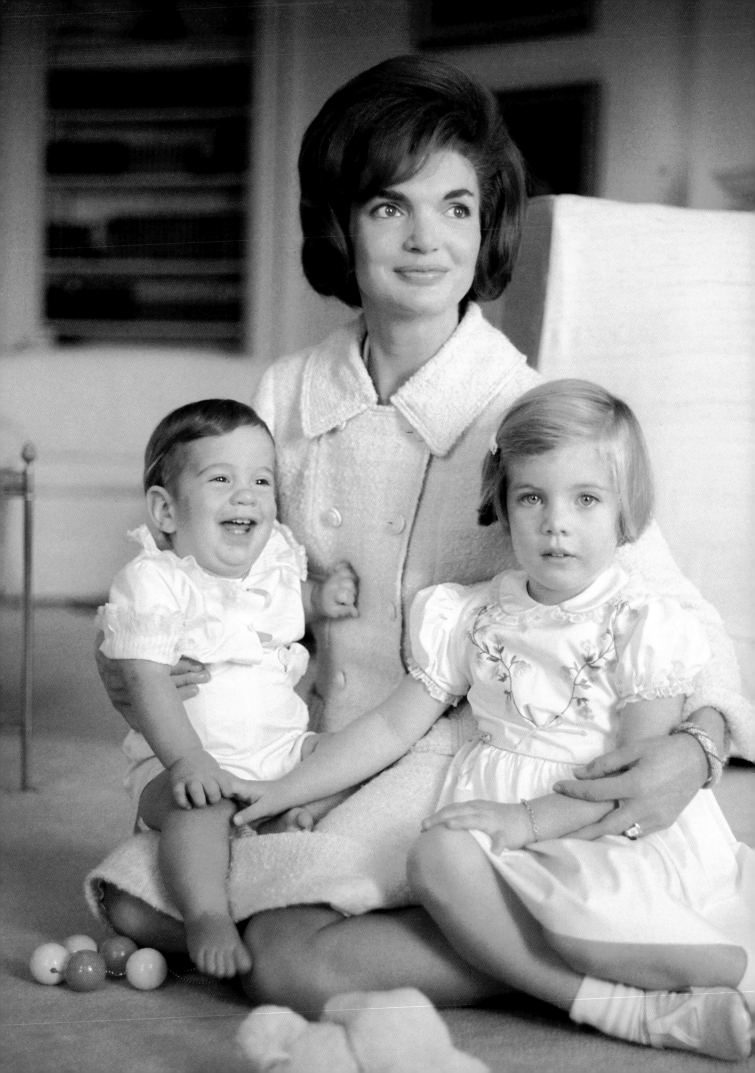

The White House

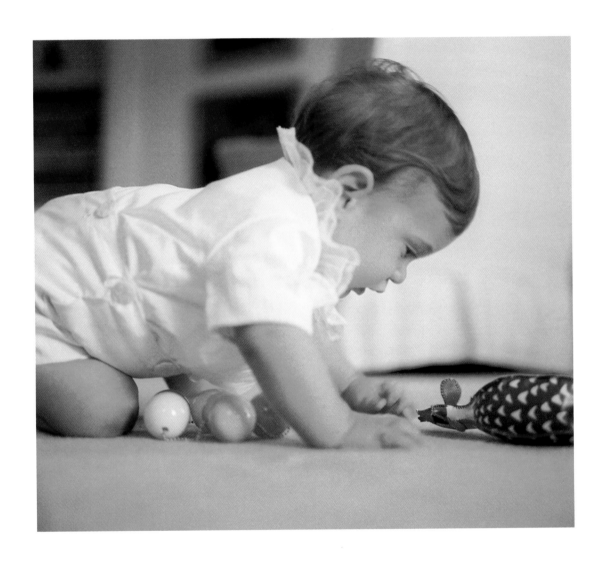

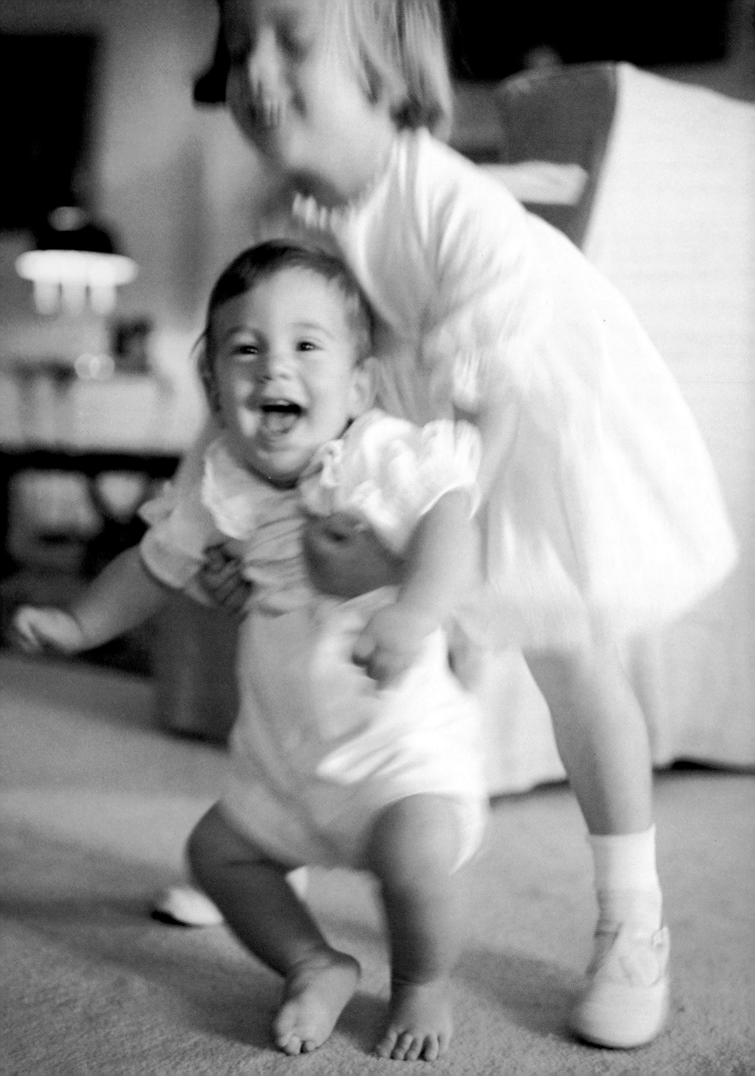

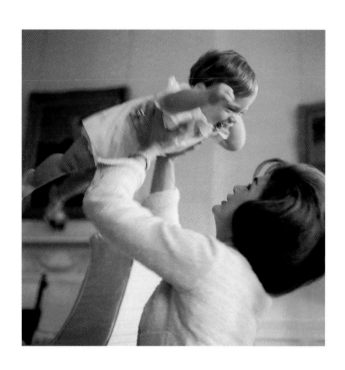

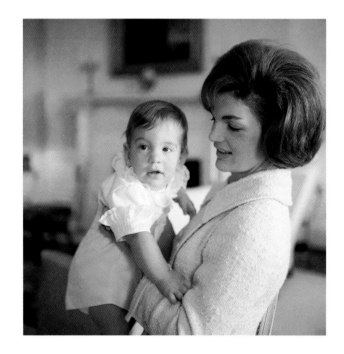

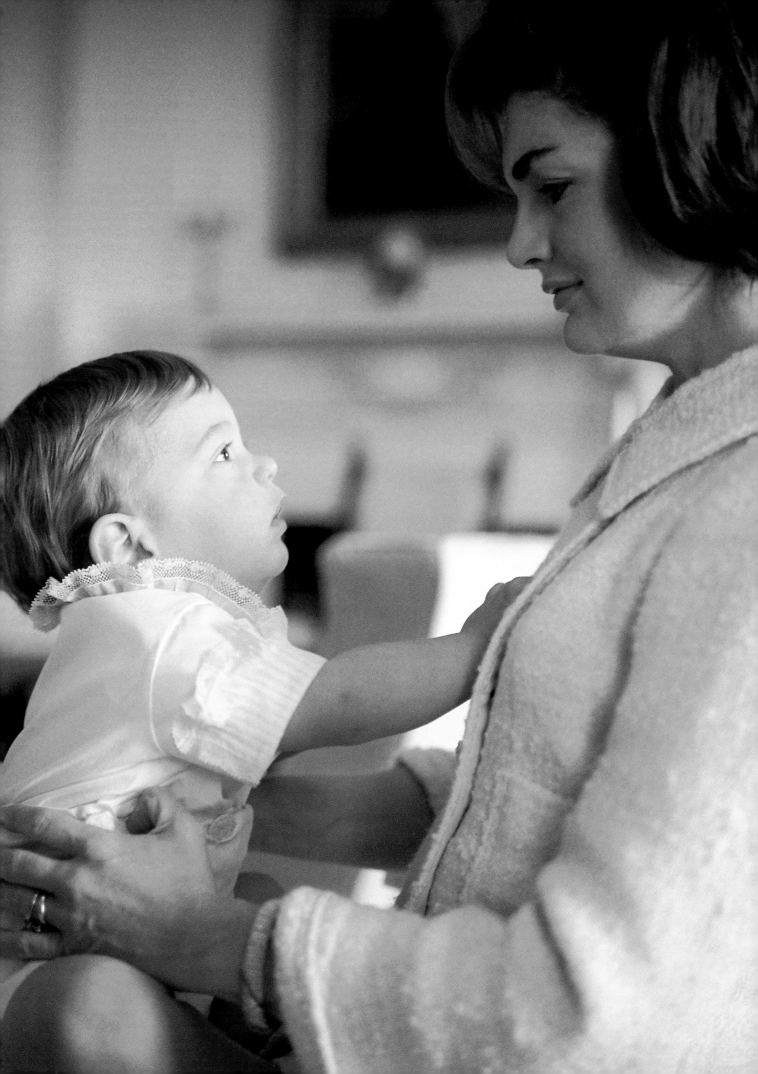

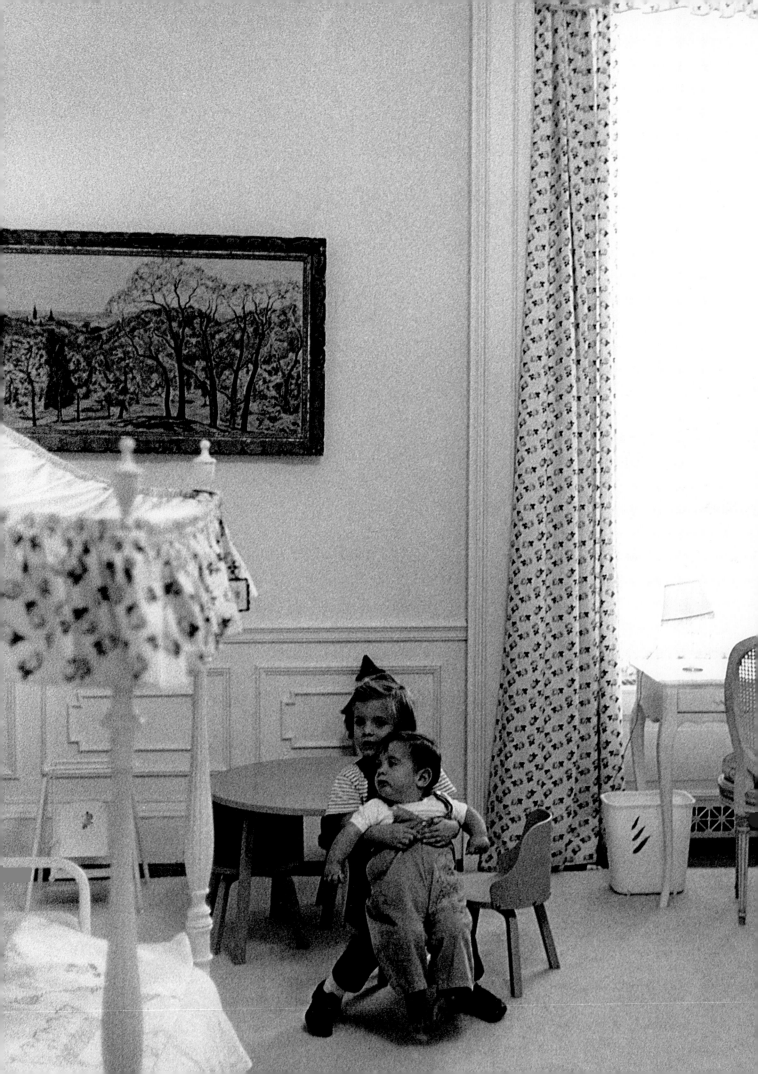

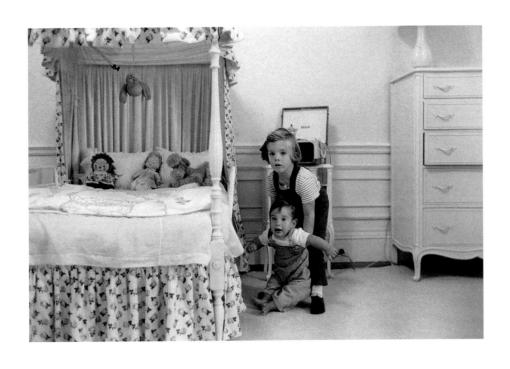

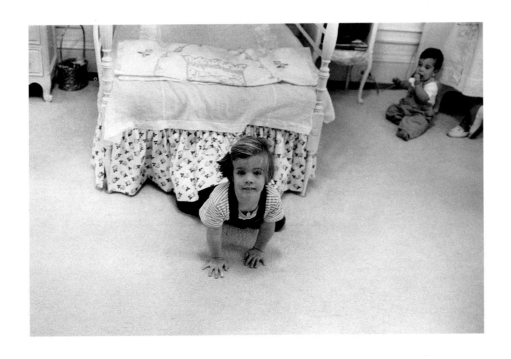

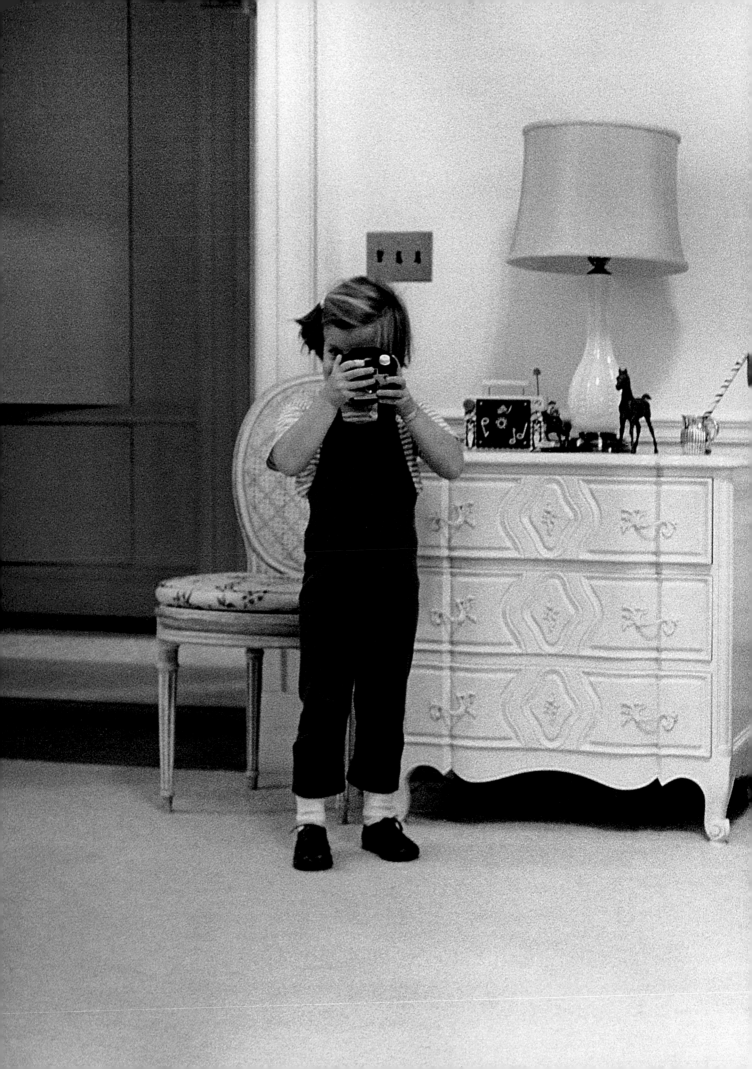

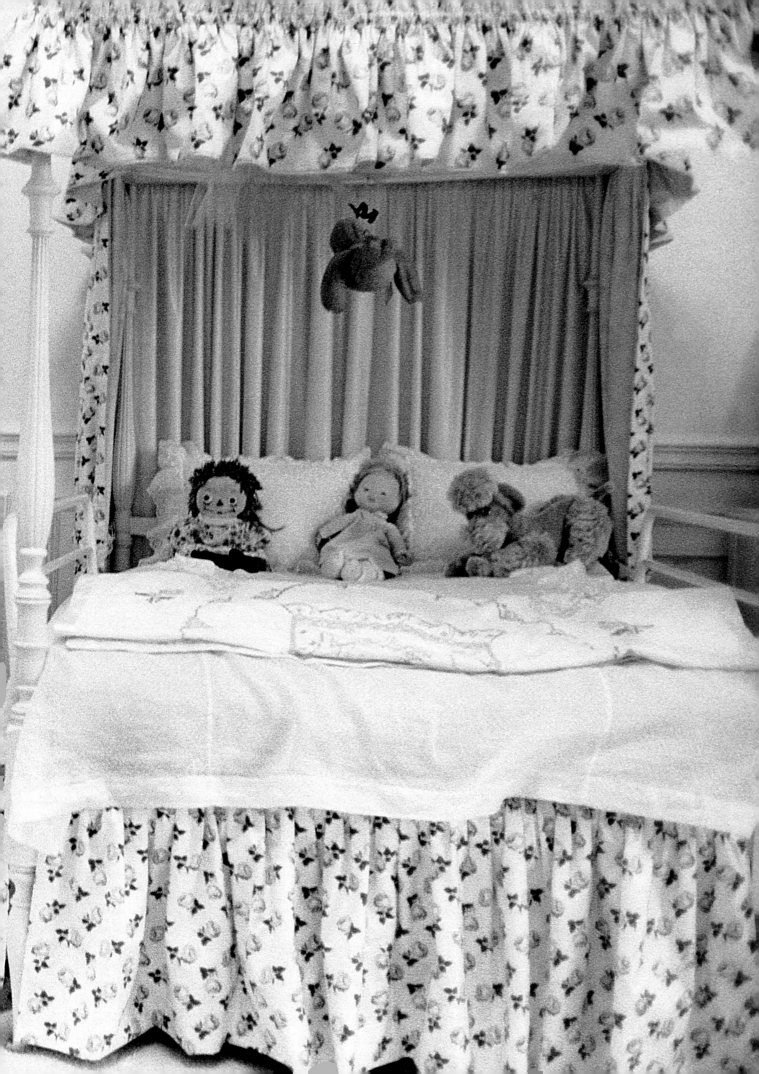

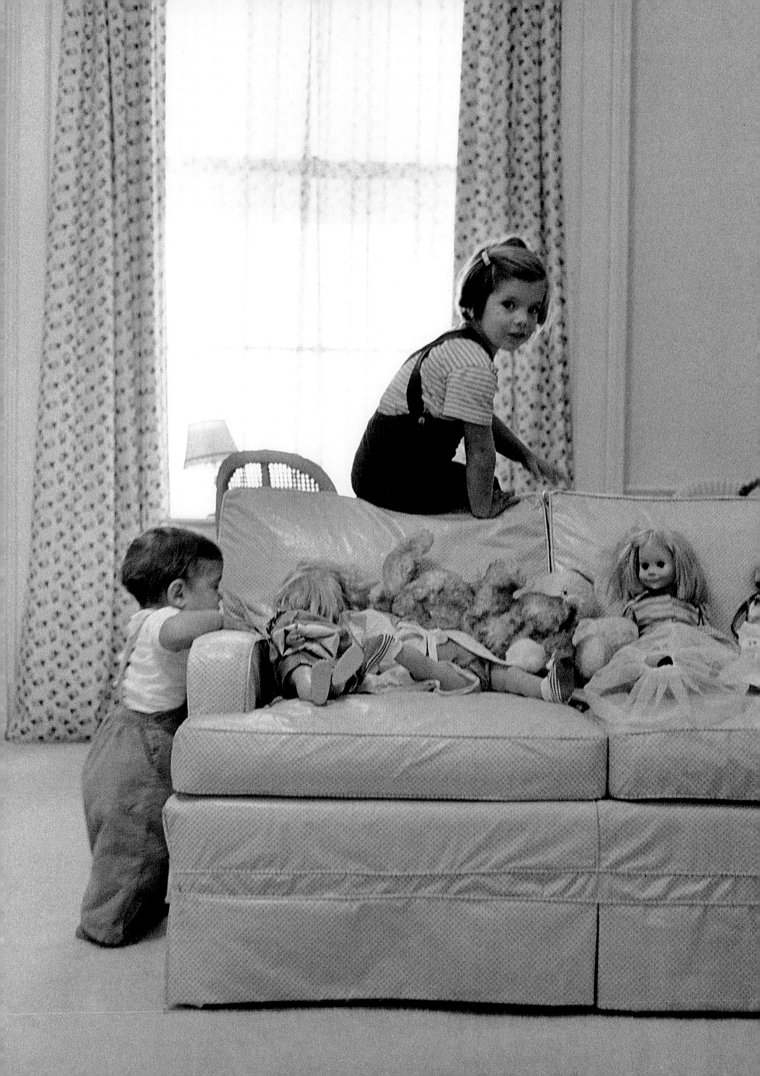

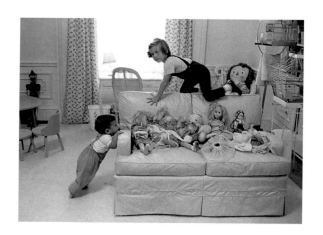

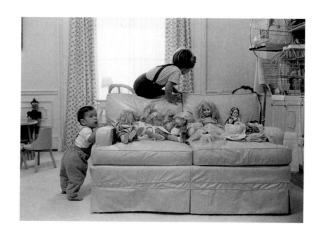

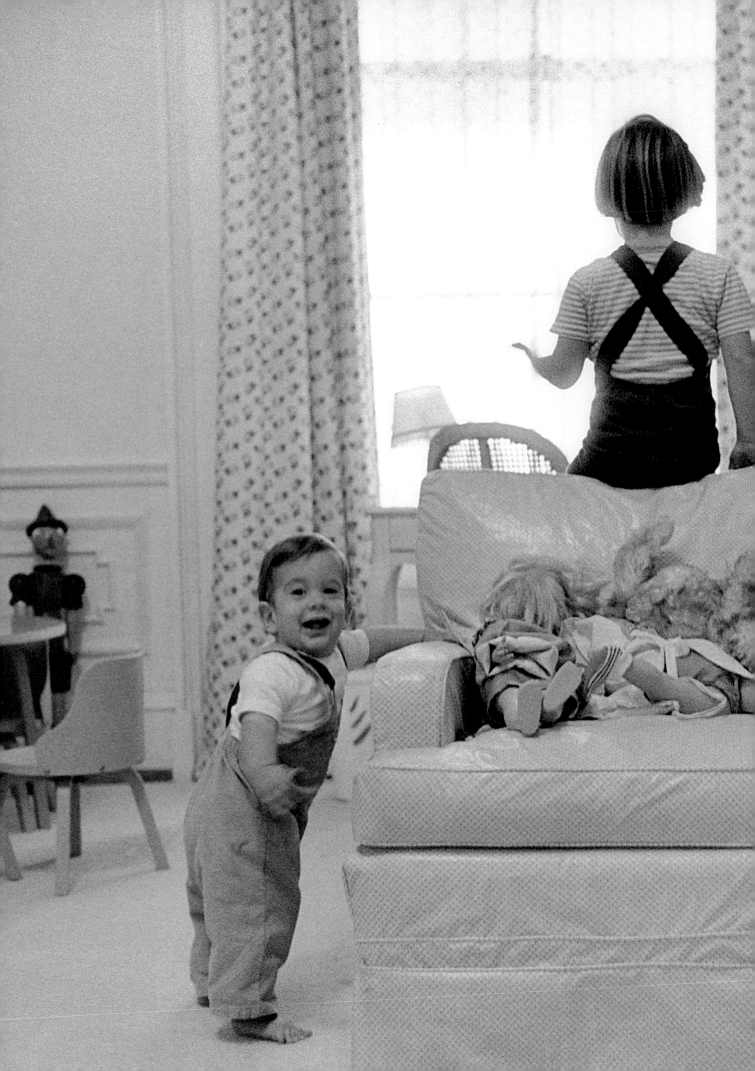

Palm Beach

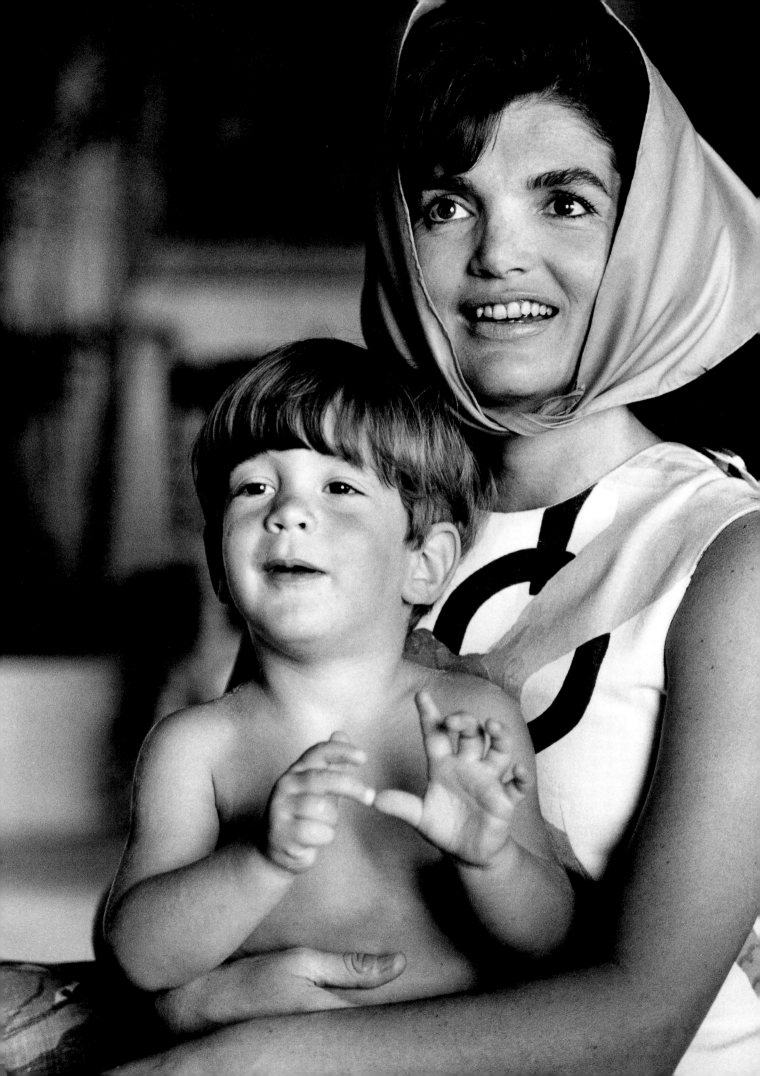

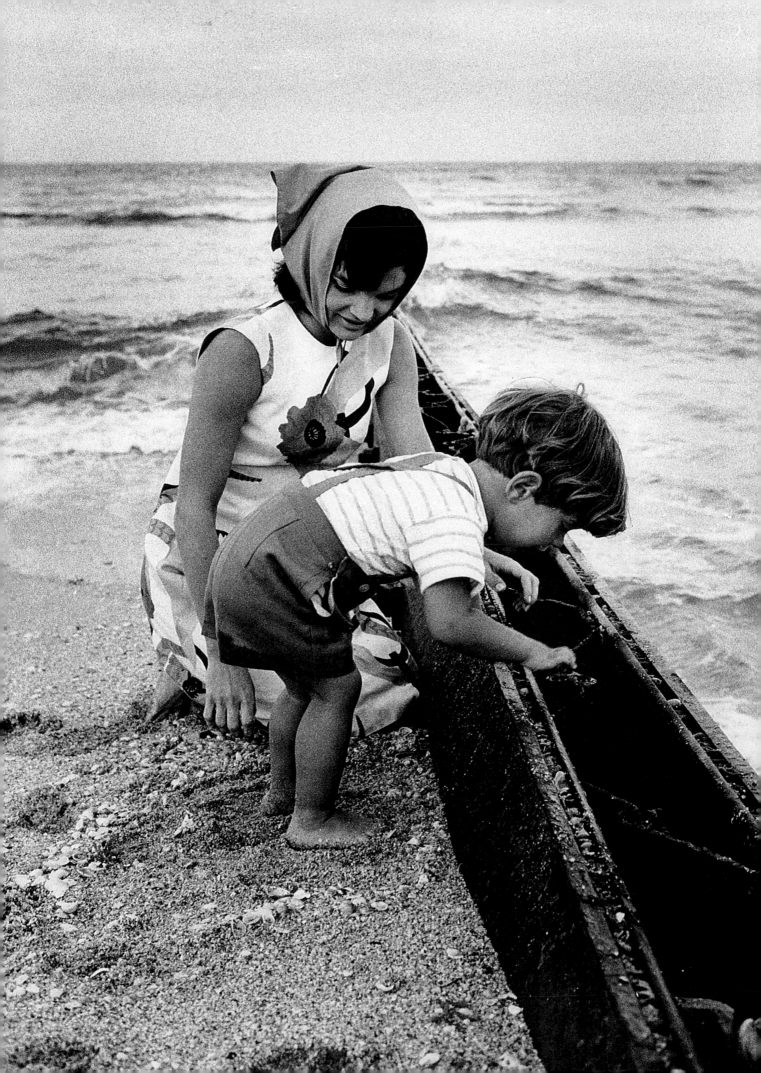

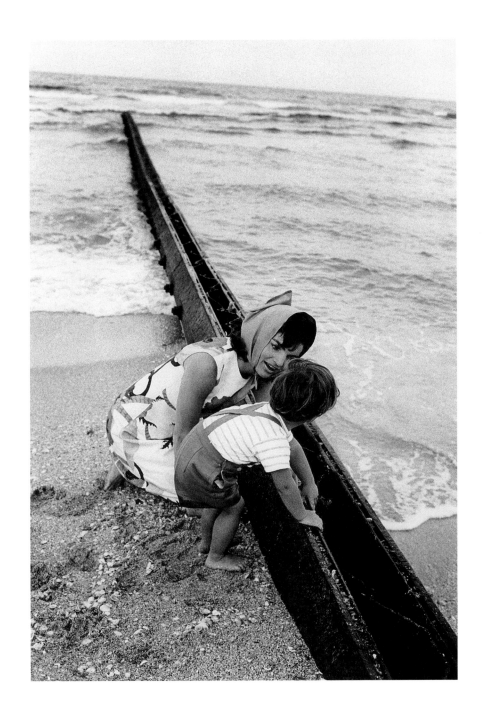

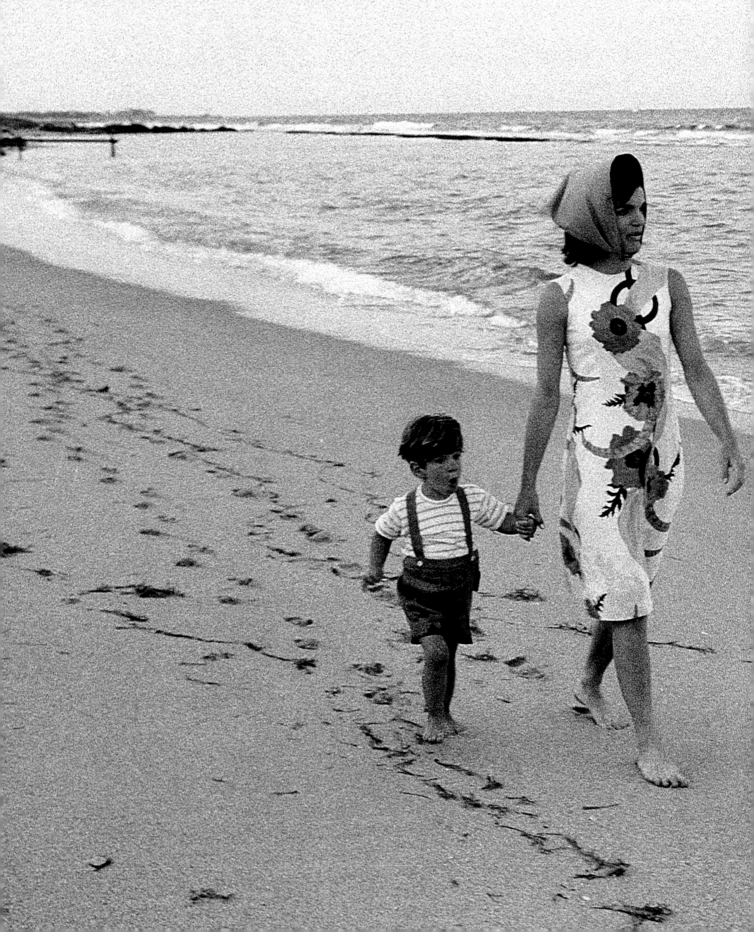

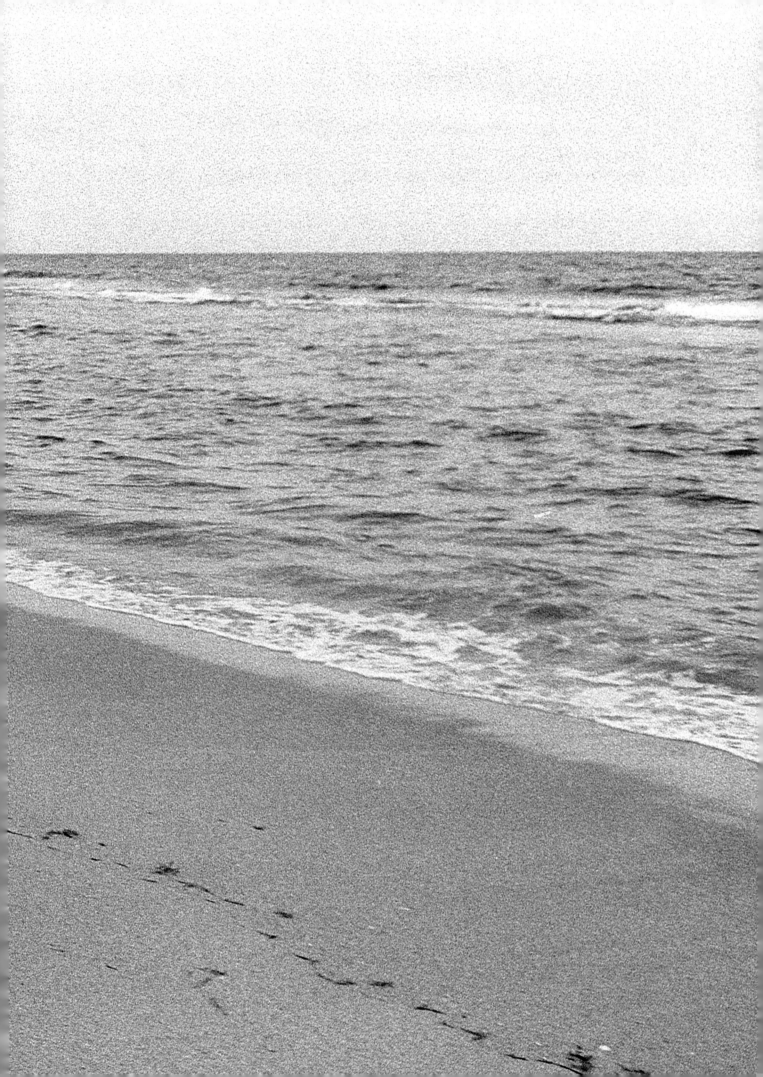

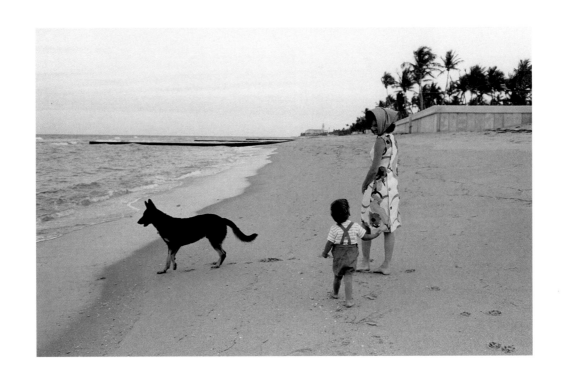

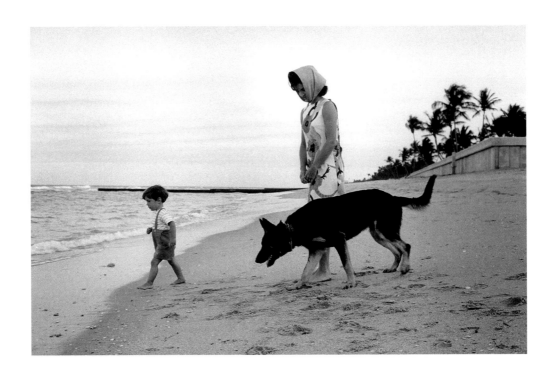

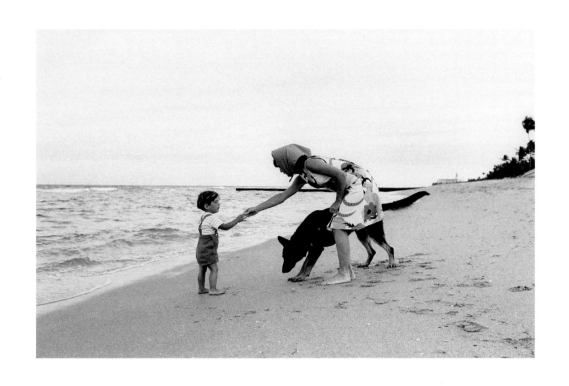

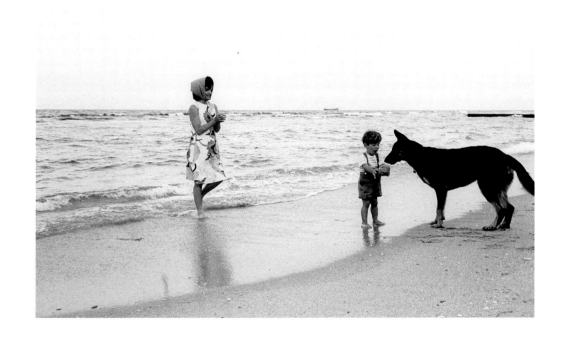

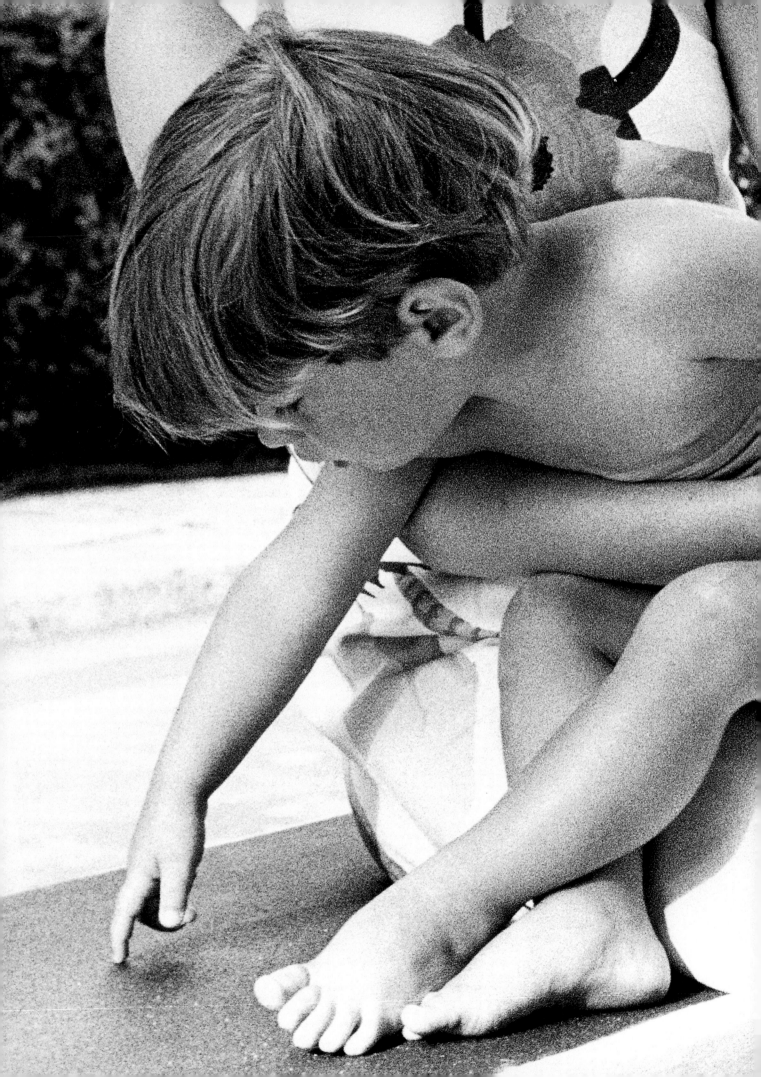

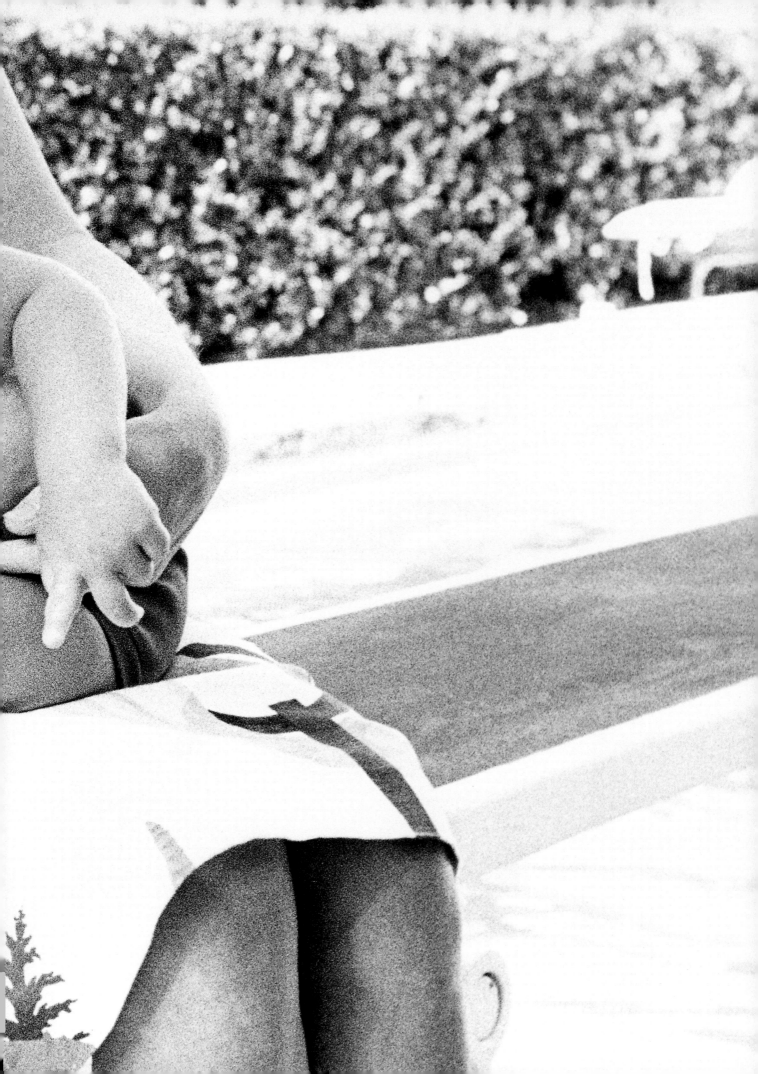

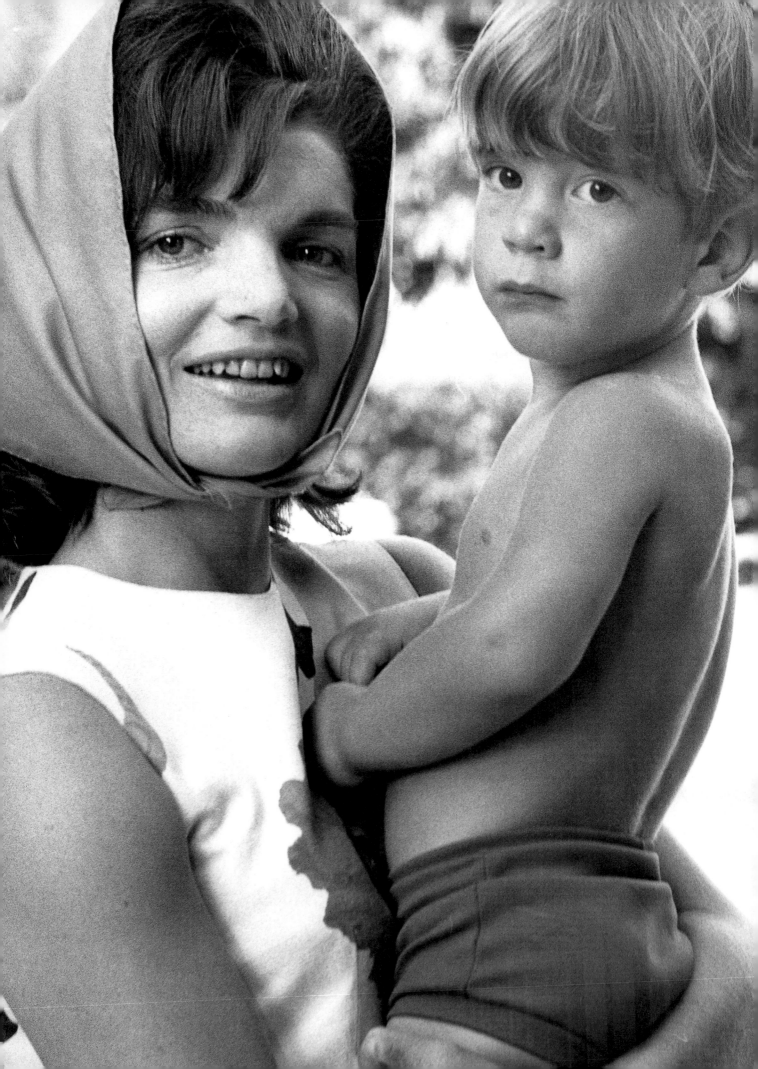

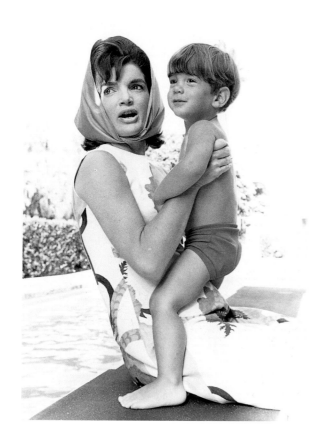

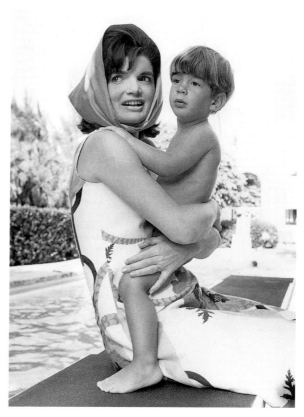

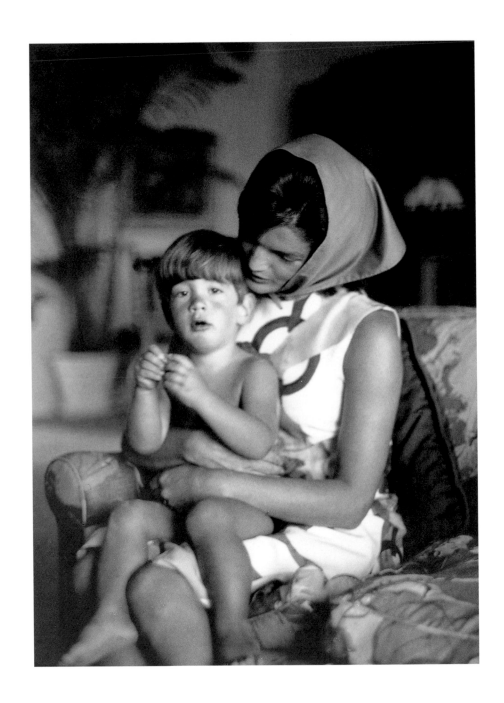

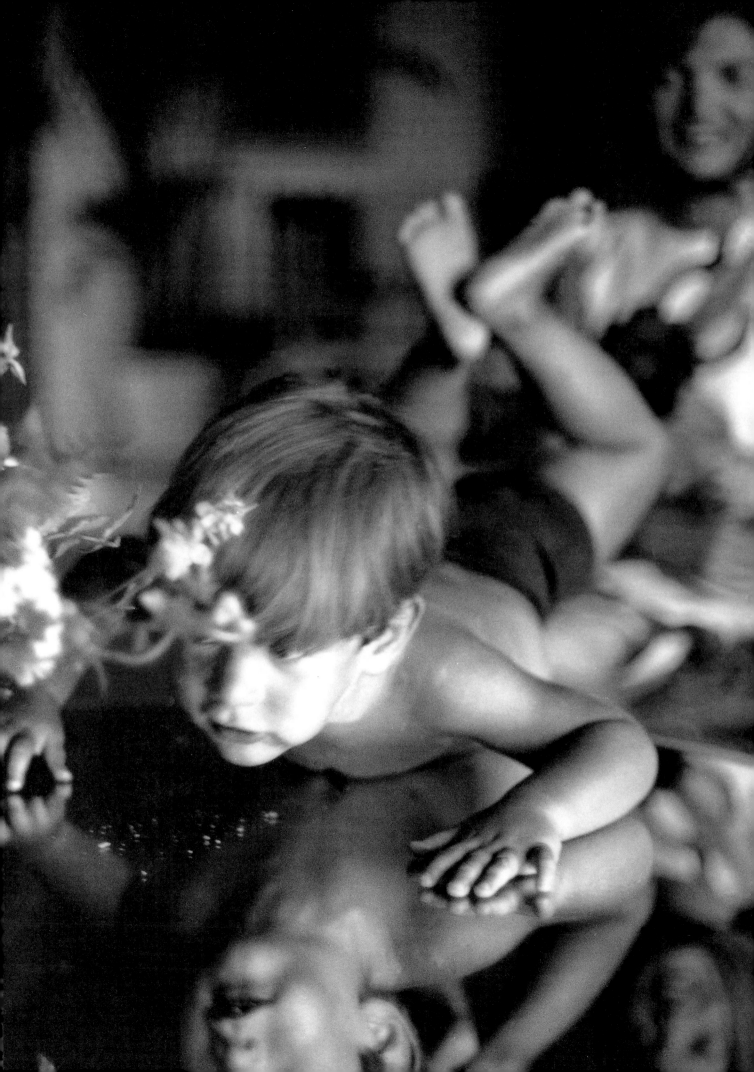

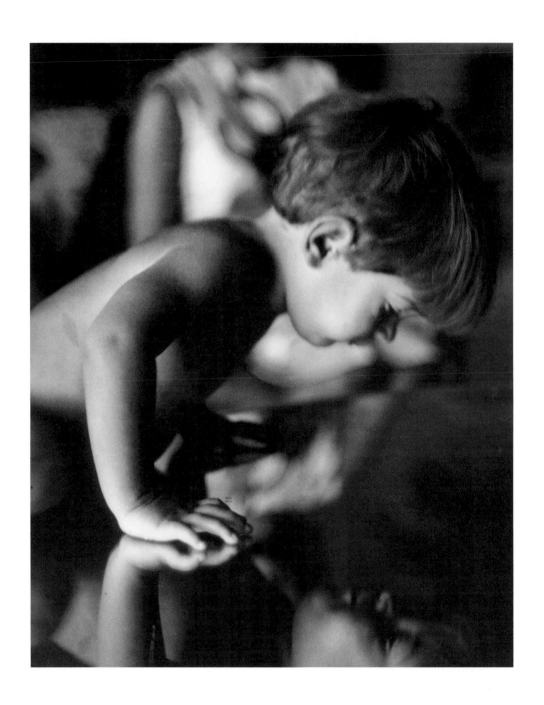

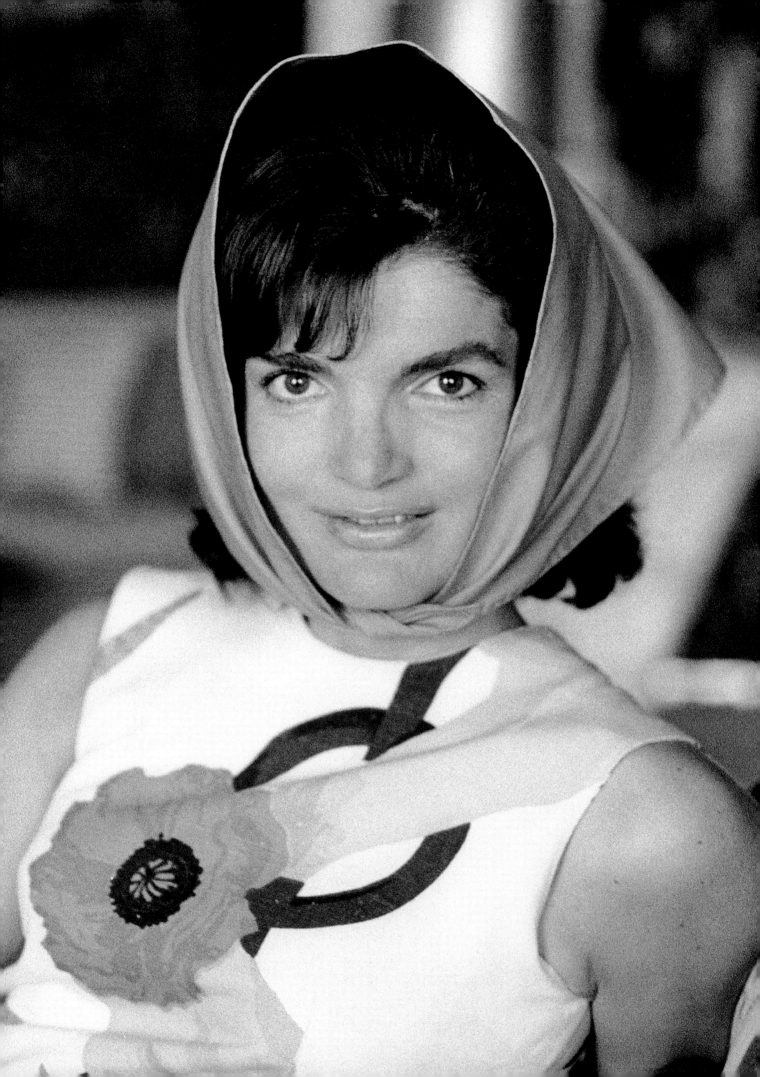

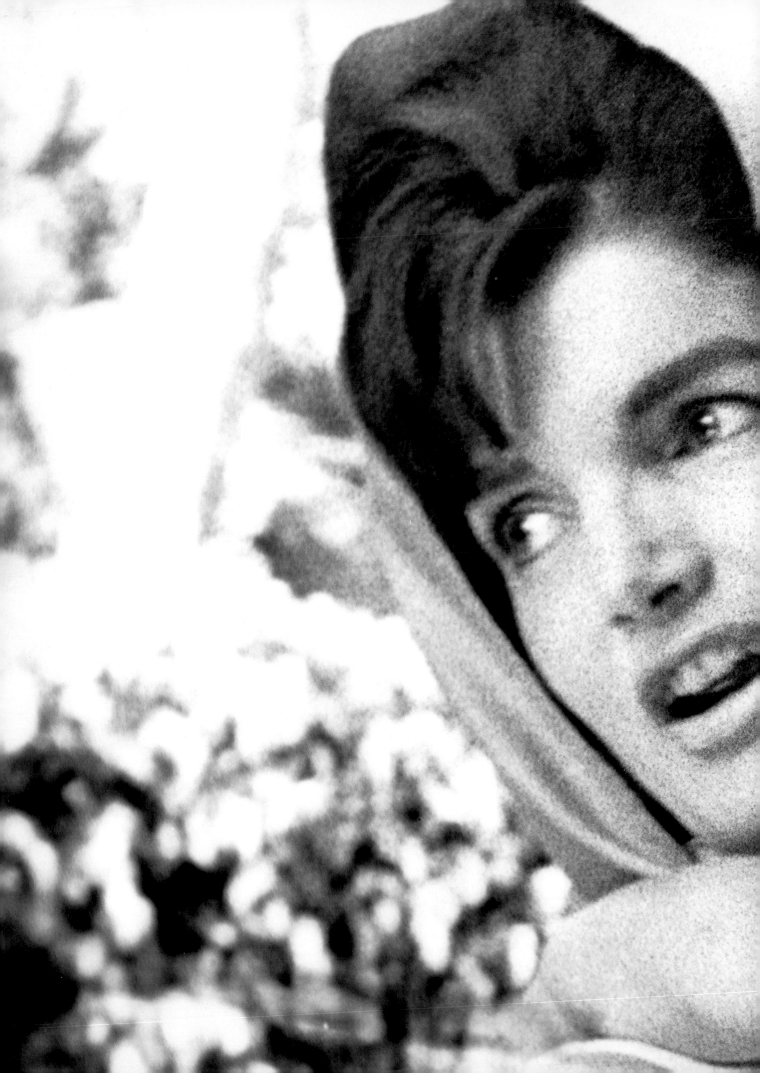

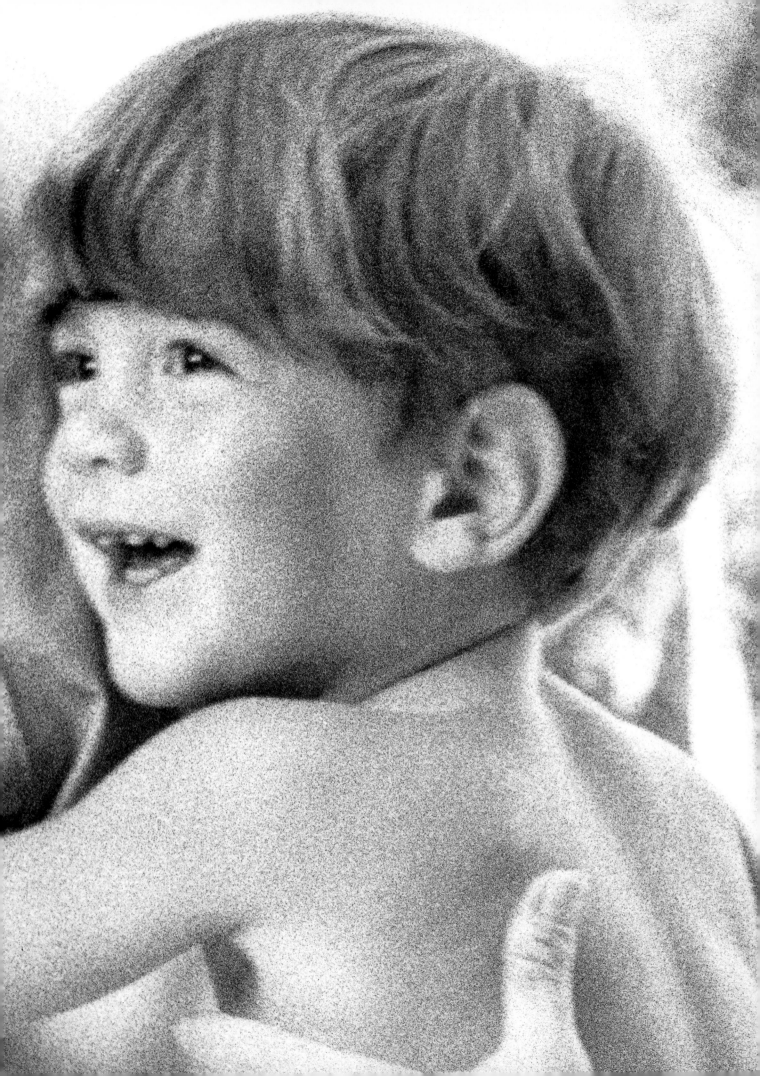

My father, Mark Shaw, died in 1969 at the age of 47. Mark spent most of my early life working, and when he died I hardly knew him. It is only now, as I sift through and archive his work, that I have begun to know and understand the man who was such an enigma to me. My father was a perfectionist; for him, creating beauty was the priority. I believe this collection of Kennedy photographs represents his finest work.

Mark Shaw first photographed the Kennedys in 1959, on assignment for *Life* magazine. That essay, on Jacqueline Kennedy, "A Front Runner's Appealing Wife," led to a close friendship with both John F. Kennedy and Jackie. Mark had a casual and unrestricted arrangement at both the White House and Hyannis Port; it was this unique position as both friend and photographer that enabled Mark to capture the informal, candid moments which make his photographs so unusual. In the four years that Mark photographed the family he traveled with them extensively, spending an average of one day per month with them. After the inauguration, Mark became the Kennedys' "unofficial" family photographer.

Mark's Kennedy photographs were well known and widely published. Two weeks before the assassination, Mark had signed the contract to produce a book. After J.F.K.'s tragic death, the book, *The John F. Kennedys—A Family Album*, was rushed into publication. The present book is an updated and revised version of that earlier one.

Mark Shaw was born in 1922. A highly decorated U.S. Air Force pilot in World War II, he went on to become a leading fashion, editorial, and commercial photographer. He worked for *Harper's Bazaar*, *Mademoiselle*, and a host of other fashion magazines. He started contributing to *Life* in 1952, and in sixteen years shot twenty-seven covers and over one hundred stories. Throughout the 1950s and 1960s, Mark shot the European fashion collections for *Life*; he was the first photographer to shoot in color at the couture shows.

Among the many famous people Mark photographed were Pablo Picasso, Marc Chagall, Brigitte Bardot, Elizabeth Taylor, Grace Kelly, Audrey Hepburn, Melina Mercouri, Danny Kaye, Cary Grant, Pope Paul VI, Yves Saint Laurent, Coco Chanel, and my mother, the singer Pat Suzuki, whom he married in 1960.

In his later years Mark began filming commercials for television. He was the winner of many awards from the American TV Commercial Festival for his broadcast work and from the Art Director's Club for his still work. Mark's Vanity Fair Lingerie and Chase Manhattan Bank "nest egg" campaigns are print advertising classics.

In 1995 my wife Juliet Cuming and I began archiving my father's work. In 1998 we established The Mark Shaw Photographic Archive. It is located in Vermont where we live with our son. D A V I D S H A W

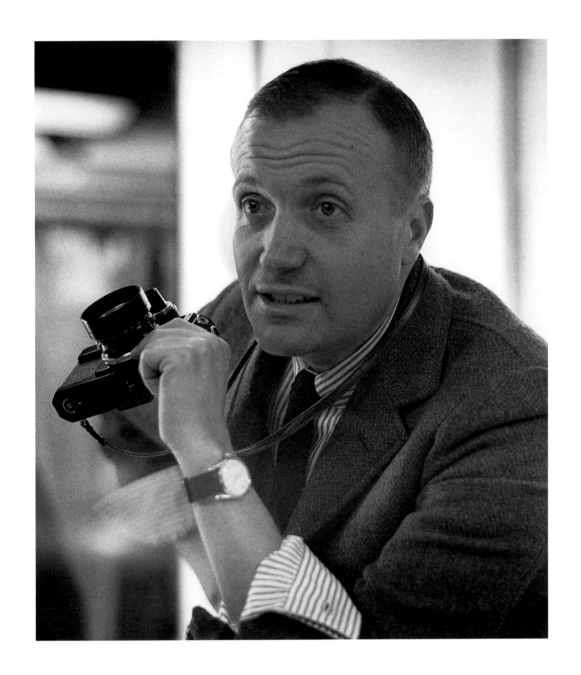

This book is not intended to be a complete photographic record or documentary of the John F. Kennedy family. The pictures are not in chronological order and I have avoided supplying specific dates, because with few exceptions the day or event was not important. For the most part these photographs are not of state occasions or ceremonies, nor do they show moments of crisis or violence. These photographs were taken in order to catch and reflect the mood, the feeling of a given moment. If the viewer receives from these pictures an understanding of the affection of the Kennedys for one another, their high spirits and enjoyment of life, the book will have fulfilled its purpose. M A R K S H A W

GEORGETOWN

Georgetown, the last weeks before the 1960 election. Breakfast early but leisurely, time to read the paper and talk and play with the children. After J.F.K. left for the Senate Office Building, Jackie would stay around the house until later in the morning, when she usually took a walk by the Georgetown canal. Her afternoon might include playing with Caroline, and the end of her day offered quiet moments.

NANTUCKET SOUND

The sailing series, taken off Hyannis Port in the fall. Sunny days and after a round of golf everyone raced to the end of the dock and went sailing. It was the practice that before the Kennedy children could sail, they would be thrown overboard in the open sea with life preservers so that they wouldn't panic when they later had an accidental plunge.

WASHINGTON, D.C.

Jacqueline Kennedy visits her husband at his office in the Old Senate Office Building, just before the election.

WHEELING, WEST VIRGINIA

Wheeling, West Virginia, a real pressure point. It was an oppressive, one-hundred-degree day, uncomfortable as could be; a small town, glass-blowing and steel, and a typical campaign kind of circus. In the basement of a church the speech was given, and there was a cake in the shape of the White

House. J.F.K. was in fine form, enjoying as always the people around him. He seemed to have boundless energy. This series, taken during a crucial campaign, went through as a blur of heat. All through this campaign there was the whirling on one side and the peaceful life in Georgetown on the other.

VIRGINIA

At the Virginia estate of Jacqueline Kennedy's mother, Mrs. Hugh D. Auchincloss, Jackie rides and plays with Caroline.

HYANNIS AND HYANNIS PORT

Returning to Hyannis. The twin-engine plane used for commuting between Boston and the Cape.

Late afternoon on the back lawn of Joseph Kennedy's house in Hyannis Port. One was always aware of the three family houses facing the tree-covered street. In front, leaves on the ground; in back, the gently rolling lawn down to the Atlantic Ocean. I was most conscious of the flow of children—the area was later aptly called the "Compound." Clothes were casual. A strong bent for the active life and also an intense life of reading, discussion of current events, and general awareness.

Typically the family was together, always celebrating birthdays, parties, anniversaries, conscious of outdoor life, the beach and the air. Most afternoons were spent along the water, walking, talking and playing with the children. Everyone would dress for dinner and gather in the living room. The talk would be on politics and the arts, and to be uninformed in that group was a disaster. World history was attacked in the manner of an athletic contest. It was the adults' world after dark.

WASHINGTON, D.C.

John-John on the balcony of the White House and J.F.K. at the Inauguration, January 1961. The inauguration gala started hours late because of the heavy snow. Less than half the guests were there at the beginning.

The White House nursery. The President, dressed to make a speech, stopped to play with John-John. Mrs. Maud Shaw, the proud nanny. Caroline, pleased to have her father there, kept playing around and finally the President scooped up John-John with a big hug and a little dance. Caroline thought of her brother as her personal doll. There was the same feeling as at Hyannis Port or Georgetown, except that this was the nursery on the top floor of the White House.

HYANNIS PORT

Color photographs made for a *Life* magazine cover story about the First Lady and for other stories.

THE WHITE HOUSE

The official photograph of John-John at one year, with Caroline and Jackie. Carolyn, the photographer's assistant, struggling to get John-John to stand. She carried the tripod and talked about my "yellow-bird" airplane. She identified the plane with the photographs.

Caroline sneaking out from under the nursery bed to play with John-John and ending up taking my picture.

PALM BEACH

Palm Beach, the time of the announcement of the impending arrival of a third child. Walking along the water. The dog Clipper playing in the water, John-John back of the house by the pool. John-John with a sense of humor and a twinkle in his eye. These were warm, happy times, with no feeling of the pressures that were to come.

ACKNOWLEDGMENTS

My deepest appreciation to:

Sam Sako, my faithful darkroom man, Trudy Owett, my personal assistant,
Clifford Wolf, my photographic assistant, and the Studio personnel: R.O., D.W., M.B., M.O., V.H.

Robert Cato, who helped select the pictures and designed the book.*

The editors of *Life*, who gave me the initial assignment to photograph John F. Kennedy.

And most of all my wife Pat Suzuki, who through the years gave me
the encouragement and time to prepare this book.

M.S.

The Mark Shaw Photographic Archive thanks the following people:

Nancy Wolff, Christopher Lyon

Brie Patterson

James Danziger, Suzanne Goldstein, Joshua Greene, Jane Kinne, Barbara Baker Burrows

Louise Fili, Mary Jane Callister, Laura Kleger

Geraldine Trotta

Fred Breunig, Pedr Seymour, Ned Gray, Bill Hooper

Pat Suzuki

And most of all Lucretia and Fredrick J. Mali.

D.S.

*THE 1964 EDITION.